IMAGES
of America

CHEROKEE
COUNTY

Published by Arcadia Publishing,
an imprint of Tempus Publishing, Inc.
2 Cumberland Street
Charleston, SC 29401

Printed in Great Britain.

Library of Congress Catalog Card Number: 00-105482

For all general information contact Arcadia Publishing at:
Telephone 843-853-2070
Fax 843-853-0044
E-Mail arcadia@charleston.net

For customer service and orders:
Toll-Free 1-888-313-BOOK

Visit us on the internet at http://www.arcadiaimages.com

CONTENTS

ACKNOWLEDGMENTS

Robert (Bob) Minnix contributed information, photographs, contacts, and identified individuals in images. Without his assistance, this book would have taken two months longer to complete. He was the major contributor of items and information in the book. I also wish to thank the following individuals and businesses for the information, materials, and assistance they provided: Paul and Melvia Salvage of Savage Photography at Pleasant Gap for a number of photographs and area information; Terry Dean, Vickie Evans Roberson, and Kerry A. Yancer of the *Cherokee Herald* for a number of photographs; Edna Smith Stephens, who provided photographs and information of Bluffton; Billy Burns of Spring Garden for photographs and information on Carmel Church and his family; Bill and Ida Ward, who furnished several pictures and explained the action in each; Linda Winkles at the Goodyear Store, who identified people in pictures; Chip Tilly for railroad photographs and information; Judith Elaine Clonts Russell for family pictures and information; Jerry Conley for information on Rock Run Commissary and houses; Frances Pollard and Erlene Harper from the Cherokee County Museum, for assisting in several ways; Earl Gardner for family photos and information; Normandee Nickels from the *Star* newspaper; Brig. Gen. (Judge) Lumpkin for information and family photographs; Amy Chester; Andrew W. Reid for a family photograph; Bill Westley, who posed with a fish he caught; J.R. Rodrequez; Tony M. Griffin, who posed for a picture; Mary Lee Tucker and Gail Poe, who assisted with information and pictures; Emily Ward and George Jordan for photographs and information; Bill O'Brien for photographs; Jimmy Reeves and Julie Balleneger for photographs; Lannie Star, who posed for a picture; Tommy Loder; David Derrick; Tara Blanchard, Beth Watts, and Nell Adder, for information they volunteered; Shelia Richardson, who posed for a photograph; and Clyde Collier Photography, which contributed technical advice.

INTRODUCTION

Man has inhabited the Cherokee County area for in excess of 9,000 years. Many civilizations have been established and have then disappeared during this period of time. The Creek Indians were the ones present when the first Europeans to keep a written record came into the area. In 1540, Hernando de Soto led an expedition from Florida through present-day Georgia, Alabama, and Mississippi. He first met with the Creeks on an island in the Coosa River. McCoy's Island is today thought to be the location of this meeting.

After winning a 30-year war with the Creeks, the Cherokee occupied the area from 1755 until their removal on the "Trail Where We Cried," in 1838. The Cherokee had attempted to adapt as necessary to satisfy their invaders but to no avail. The federal government's greed for their property cost the Cherokee their land.

In 1836, Cherokee County was formed from what had been Jackson County, Benton County, and Saint Clair County. The first courthouse was made of logs and located in Cedar Bluff. The name of the town was at that time changed to Jefferson. The name was changed back to Cedar Bluff in 1842 after it was discovered that Alabama already had a town named Jefferson. In 1844, it was determined that Centre was indeed near the geographical center of the county and the courthouse was moved here. Three courthouse buildings preceded the current one, which was built in 1937.

Since the founding of Cherokee County, 259 towns or communities have been established. Many of these do not exist today. Bluffton is a good example. In the late 1800s, Bluffton was a boomtown with approximately 8,000 citizens. Today, only the church and one house are left from what was the town.

As families of European descent began entering the area, there were only the rivers and Native-American paths on which to travel. The Cherokee realized the advantage of roads as trade routes and began to construct them. They also built ferries to take people and cargo across the rivers. When the Native Americans were removed, rivers were still the primary method of travel. More roads were built when the new government took over, and because rivers were still the main obstacles, individuals constructed and manned more ferries. In 1917, there were 13 ferries operating in the county. Some of the first bridges in the county were covered bridges. Transportation in the county has advanced from riverboats and wagons to modern roads and air systems.

In 1917, Cherokee had 76 towns, according to the W.W. Ward Company Surveyor Map dated September 1, 1917. Today Centre, Cedar Bluff, Leesburg, Gaylesville, and Sand Rock are

the only incorporated towns within the county. At one time, the county had 114 post offices, but few rural post offices remain today. In 1891, the *Bluffton Mascot* newspaper described the county as "the shape of the finger of destiny seeming to beckon people to come-hither."

Several important things occurred in Cherokee County during the Civil War. After the "Battles for Atlanta," the remainder of the Confederate Army that had been defending Georgia went west and General Sherman's army followed them. General Hood made his headquarters in Cherokee County before moving north to join another Confederate Army in western Tennessee. Sherman saw that Hood was pulling him away from his objective and stopped the chase. Sherman stayed in Cherokee County for a few days prior to beginning his infamous unopposed march through Georgia.

Farming has played an important role in advancing civilizations for hundreds of years. Farm methods have changed through time from scratching out the earth with wooden tools to the use of modern machinery. Today, a single person with the right equipment can accomplish in a day with far better results what it once took many men and women to do. Farming has always been the most important industry in Cherokee County and continues to be so today. Cotton, corn, soybean, wheat, and hay are the main cultivated crops in the county. Cattle farms, dairy farms, and raising poultry for meat and eggs are also big in this area.

Churches have played an important role in the county from the start. They were the first to begin educating children in the basics of reading, writing, arithmetic, and voice. A pamphlet from the Gaylesville Academy states "Gaylesville Academy stands for physical, mental, moral and Christian education." It was not until the mid-1900s that churches were separated from schools because of an interpretation of the first amendment of the United States Constitution.

Cherokee County is diversified in its industries and trades. Plant nurseries provide wholesale trees, shrubs, and seasonal and annual flowers to most of the largest retail outlets in the eastern portion of the United States. Farm products from Cherokee County are distributed far and wide. Manufacturing plants produce items sold nation-wide. Tourism is big and ever-growing. Families from Kentucky, Illinois, Indiana, Ohio, and other locations take their yearly vacations in Cherokee County because of the excellent fishing in Lake Weiss.

In this book, a reader/viewer is taken from the year 1540 through time with the use of photographs and captions.

One

THE AREA'S
EARLY INHABITANTS

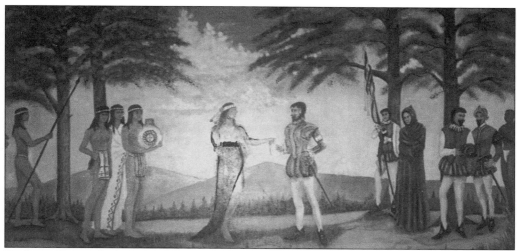

Explorer Hernando de Soto entered what is now Cherokee County, AL, in 1540. This area was at the time a part of the Muckhogean (Creek) Nation, a religious people whose God was Yahweh. This is one of the four names of God mentioned in the Old Testament. De Soto was welcomed into their village and given food and comfort. De Soto's log of this journey is available today from several sources. Ed Byers painted the picture shown here, which portrays the Creeks welcoming de Soto.

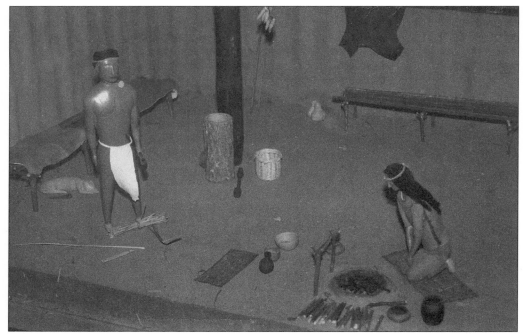

The Creeks lived in houses constructed of wood covered by a masonry material made from clay, straw, and water. The model above represents the interior of a home in the 16th century. They had never heard of tepees, which were used by American Indians who lived on the plains and in the Great Lakes regions during a hunt. These plains Indians returned to their houses after the hunt.

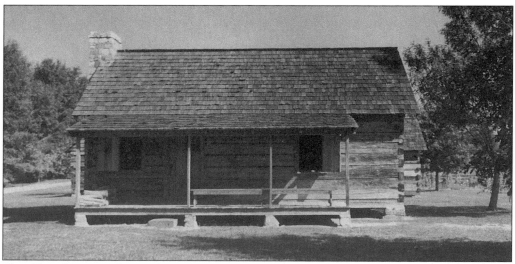

The Cherokee moved into this area in 1755. By the mid-1700s, the Cherokee had advanced their houses from clay to log cabins. Iron axes, introduced to them by Scottish traders, made it easier to hew trees into logs of the correct shape. Shown is a typical Cherokee home, c. 1800. Several individuals prospered by establishing businesses, thus allowing some to build brick houses. By 1800 their standard of living was equal to whites in the area. Many of these houses still exist today.

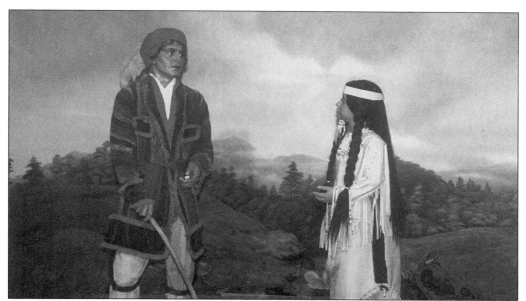

Sikwoyi (Sequoyah) was at one time a resident of Cherokee County. He was spoken of as a genius capable of accomplishing anything he desired to do. Among other accomplishments, he tamed wild horses, and was a blacksmith, a silversmith, an artist, and a soldier. He created the Cherokee alphabet and written language. He is often compared to Cadmus, who created the Greek alphabet. This picture of Sequoyah and his daughter Avoca is a scene from the Sequoyah Museum in Monroe, TN.

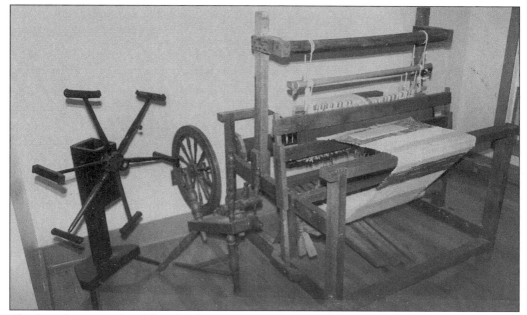

The furnishings inside a Cherokee home, c. 1800, were modern for the time period. A spinning wheel was used to make thread from wool or cotton. A loom was then used to weave cloth from the thread. The cloth was made into one of its many uses, like clothing for the family. Several people established weaving businesses to make cloth for others.

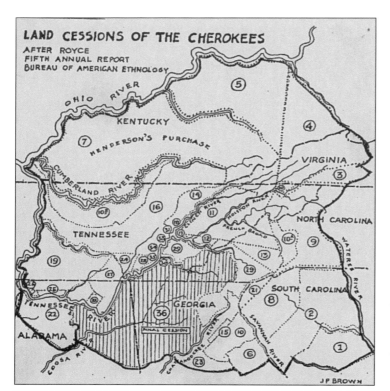

LAND CESSIONS OF THE CHEROKEES
AFTER ROYCE
FIFTH ANNUAL REPORT
BUREAU OF AMERICAN ETHNOLOGY

In 1755, the Cherokee people defeated the Creeks in the final battle of a 30-year war. The Creeks then abandoned the upper areas of Georgia. The Cherokee Nation was then as the map shows it. As Europeans, and later Americans, desired more land, the Cherokee ceded land to the greedy invaders. In 1802, Georgia sold all lands west of the current Alabama/Georgia border. It did not matter to them that several American Indian Nations were located in this area. In 1819, the state of Alabama was created from a part of this sale.

PREAMBLE TO THE CHEROKEE CONSTITUTION

We, the Representatives of the people of the Cherokee Nation, in Convention assembled, in order to establish justice, ensure tranquility, promote our common welfare, and to secure to ourselves and our posterity the blessings of liberty; acknowledging with humility and gratitude the goodness of the sovereign Ruler of the Universe, in offering us an opportunity so favorable to the design, and imploring His aid and direction in its accomplishment, do ordain and establish this Constitution for the Government of the Cherokee Nation.

When the English arrived on this continent, they declared the natives to be sub-human savages. This eased their consciences and allowed them to do as they wished with the Native Americans without feeling guilty. However, the Cherokee Nation was civilized. Their God was Yo-Ho-Wah, and many think this was Jehovah. They adapted to the newcomers in a vain attempt to save their nation. The preamble of the Cherokee Constitution and the constitution itself were a part of these actions.

Two

THE EARLY HISTORY
OF CHEROKEE COUNTY

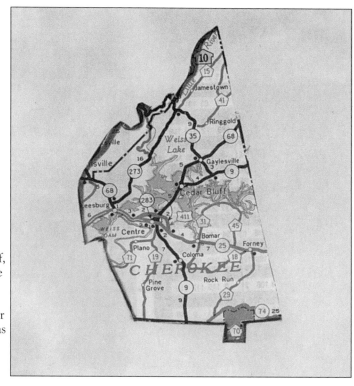

Cherokee County had 76 towns in 1917 according to the W.W. Ward Company Surveyor Map dated September 1, 1917. Since it was founded, 257 towns or communities and 114 post offices were established in Cherokee County. Today Centre, Leesburg, Cedar Bluff, Gaylesville, and Sandrock are the only incorporated towns within the county. In 1891, the *Bluffton Mascot* newspaper described Cherokee County as "the shape of a finger of destiny seeming to beckon people to come hither."

In 1843, Cedar Bluff had a newspaper, dry goods stores, a jewelry store, a livery stable, a blacksmith shop, and a gristmill, and was the county seat. This photograph shows a part of the old section of town. Today, Cedar Bluff is a modern progressive city. When Lake Weiss was built, a part of this town went underwater. However, the lake has attracted new residents and created a tourist industry.

Communities and towns began to be established in Cherokee County in the 1830s. It was 1886, however, before any were incorporated. Gaylesville became the first incorporated town in the county. It was named after a Cherokee Indian who lived there. The early town had a buggy shop, harness shop, carpenter shop, Presbyterian church, four doctors, and a calaboose. The first school in the county was established here in 1853, and the first bank opened in 1906. Shown here are today's city hall and fire station.

Moses Hampton helped survey and lay out the town of Centre in 1844. He was a preacher, furniture maker, and builder of churches and cotton gins. He invented brushes that upgraded and improved the machinery within cotton gins. He was one of the builders and an honorary member of the first church built in Cherokee County. This photograph is not of Moses Hampton but represents how he might have looked in his old age. His contributions to the history of Cherokee County were too important not to have been included in this book.

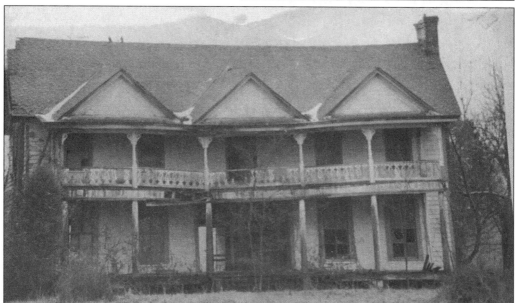

Many grand antebellum homes were constructed between 1850 and modern times. The house in this photograph represents the early years. Most homes built in the 1800s have been destroyed in one way or another. This one that was in Centre was a fine example of houses built before the beginning of the 19th century.

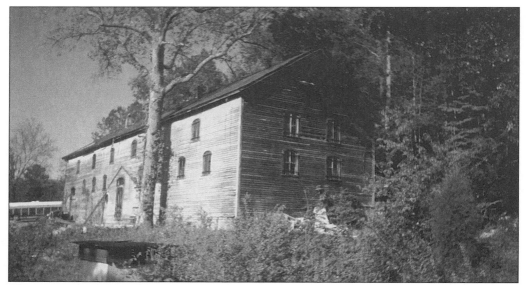

The commissary at Rock Run Furnace, built in the 1880s, supplied the furnace workers with food, clothing, dry goods, and a post office. It was equipped with a cargo elevator that may have been the first in the county. The furnace paid the workers in script, which was used to purchase items from the commissary. Items not normally stocked could be ordered through the commissary. Jerry Conley is presently restoring the building.

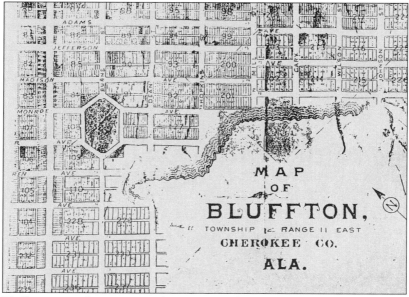

In 1890, Bluffton was a thriving city of approximately 8,000 residents. There was an electrical generating plant, a water works, churches, a newspaper, a hotel, a school, and a post office. Incorporated businesses included the Bluffton Land, Ore and Furnace Company; the American Arms Company; the Signal Land and Improvement Company; the Bluffton Carwheel Company; and the Newark Land Company. The photograph shows a small portion of a map of the town accomplished by the J.F. Falconnet Company from Nashville, TN. The map is dated March 1890.

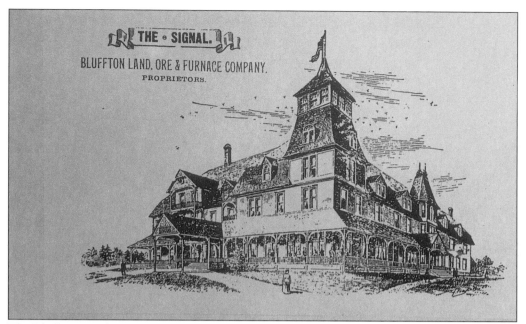

The Bluffton Land, Ore and Furnace Company constructed one of the finest hotels in Alabama and 200 houses in 1890. The Signal Hotel played host to many dignitaries, including famous English author Rudyard Kipling. This hotel was the first structure in Cherokee County furnished with electric lights. In 1950, it was torn down and the materials were used to construct the Pleasant Gap Tabernacle. A storm in the 1940s had destroyed most of Bluffton.

The University of the Southland was planned for Bluffton and city officials donated $500,000 to get it started. Its estimated construction cost was approximately $2 million. The architectural plans were compared to West Minister Abbey of England. A ground-breaking took place April 24, 1889, with dignitaries from all over the country in attendance. However, due to the failure of iron ore mines, the college was never built.

Mr. Signel incorporated the Signel Land Improvement Company in the 1880s. His company built houses, sold and mortgaged real estate, and was involved in many business construction projects. When the iron ore mines closed, Mr. Signel purchased a large part of what had been the town of Bluffton.

"Joe L. Salvage was Chief Clerk of Cherokee County Probate Court from 1890 until 1901. He was twice elected Alderman and was a promoter of business enterprises for common wealth. He was born in Goshen Valley on September 2, 1870. Joe L. Savage married Mary Darnell on January 21, 1890." This information was printed in the *Coosa River News*, a newspaper located in Centre, on March 29, 1901.

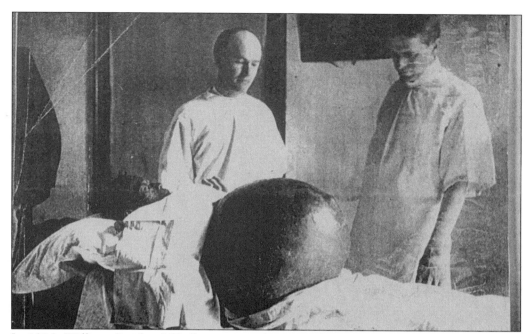

In 1906, William Smith of Bluffton was made aware that a woman from one of his share cropping families had a large tumor. Upon investigating, he discovered that her stomach was so large that she was carrying it around in a wheelbarrow. He sent for Drs. William P. and Robert M. Harbin of Rome, GA. The doctors performed an operation on the woman's kitchen table and successfully removed a giant cyst. The lady survived and lived for several more years.

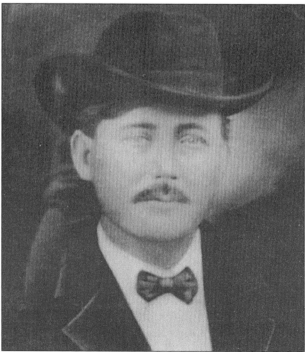

William A. (Belltree) Smith is still a man of mystery today. Some accounts of him say that he was a kind and loving man and father, while others were more bizarre. He was a landowner, farmer, and businessman who became a legend because of his mannerisms. He created a blind tiger as a means of support for his sister, who ran it. Smith imported Scotch Liqueur from the Northeast for her to sell; she never sold white lightening.

One of the first banks in Cherokee County was in the above building. Banks at this time were generally family owned and their business dealings were mostly with friends and neighbors. The officers of the bank had their desk near the front of the building for greeting customers as they entered and thanking them as they left.

The Jordan General Merchandise Store, which opened in 1920, was the largest building in downtown Centre for many years. The variety of inventory carried by the store can be guessed at by the items shown outside the building in this photograph. The store was located here until its closing in the 1970s. The Cherokee History Museum is currently located in the building.

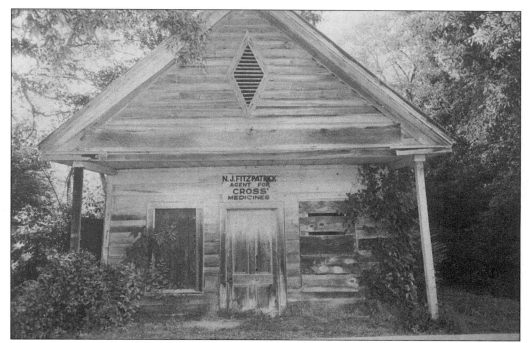

This building was a medical clinic. N.J. Fitzpatrick, an agent for Cross Medicines, and Dr. John Shamblin had their offices here in the early 1900s. As you can see, the practice of medicine has come a long way since then.

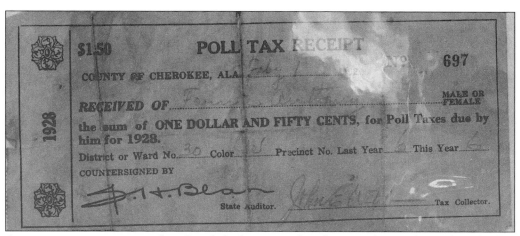

At one time, voting was not free. People had to prove that they were literate by reading the first line of the United States Constitution and paying a poll tax. This receipt shows that Forrest Authaury met the reading requirement and paid his poll tax, making him eligible to vote in the 1928 election.

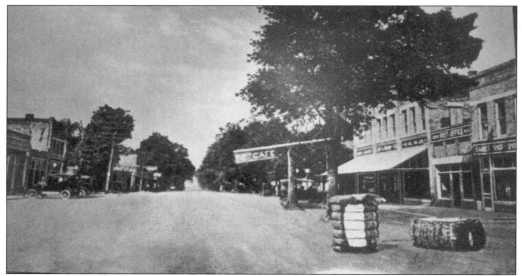

Main Street in downtown Centre looks almost deserted in this *c.* 1920 photograph. Notice the bales of cotton waiting removal by the purchaser, the sign on a pole directing travelers to the cafe across the street, and the then-modern cars. The founding fathers of Centre were clever when they planned the broad Main Street, because it has allowed the building of today's four lanes through town without destroying structures.

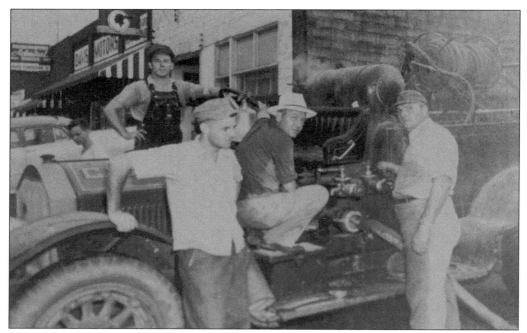

Cherokee County officials have always tried to provide adequate fire-fighting equipment for its inhabitants. Mark Garrett, Ernest Brannon, Sidney Griffis, and Charles Griffis inspect their fire truck in 1917.

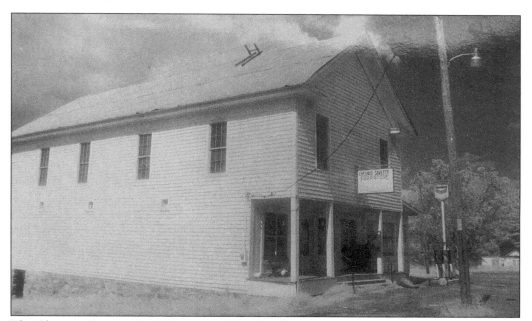

The Chestnut Savette Food Store served Gaylesville patrons for over 40 years with all manners of food products. General groceries, a meat market, and a soda fountain were all found within the store. Mr. Chestnut was said to have the finest cuts of meat to be found. This building is the oldest structure in Gaylesville that is still open as a business today. It is now a used furniture store.

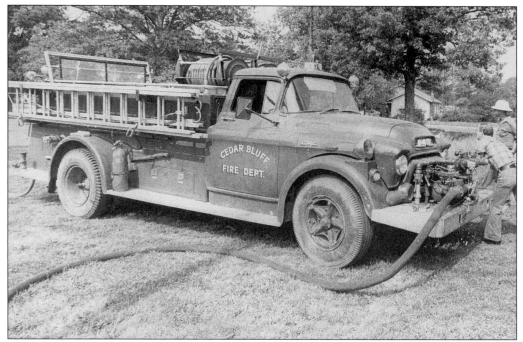

In this *c.* 1960 photograph, members of the Cedar Bluff Fire Department are keeping the water flowing from a street hydrant through the pumper truck to a hose being used to fight a fire.

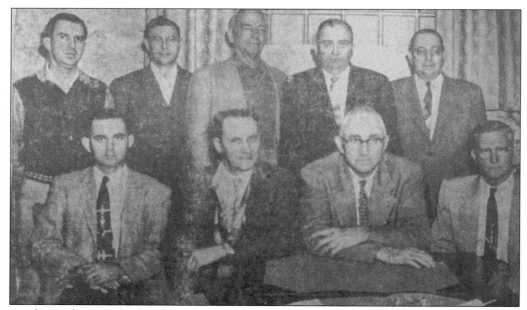

At the 10th annual Chamber of Commerce Banquet, held on April 11, 1956, Jim Jones assumed the chamber presidency. "We must aim high," he called to members. T.H. Hagan was the principal speaker for the affair. From left to right are the following: (seated) Charles Forrnby, Frank C. Ingram, Jim Jones, and Irby Keener; (standing) John Ellis, Jack Livingston, Charles Ward (outgoing president), J.B. Burkhalter, and Glen Williamson.

Jimmy Morrison and Sharon Burkhalter (right) seem to be enjoying the paper they're are holding.

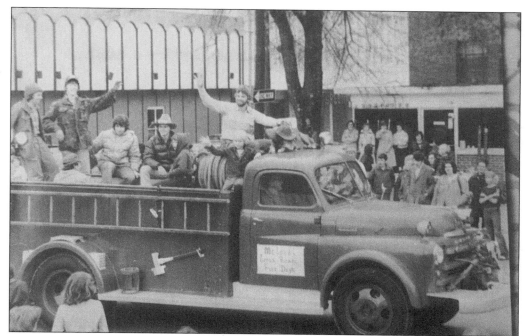

This truck's crew from the McLord's Cross Roads Fire Department is obviously enjoying themselves while they parade in Centre. No one in the picture has been identified. The police department and part of the courthouse is visible to the right behind the people who are viewing the parade.

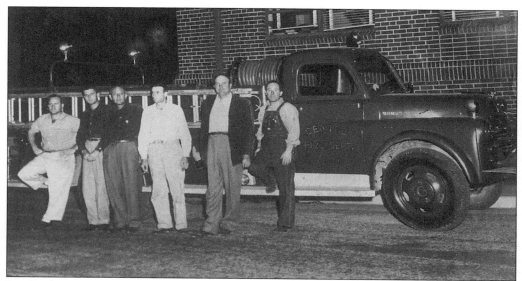

Joe Cockran, Ernest Brannan, Sidney Smith, Pete Reed, Mack Garrett, and Charles Griffis stand beside a city of Centre fire truck in 1948.

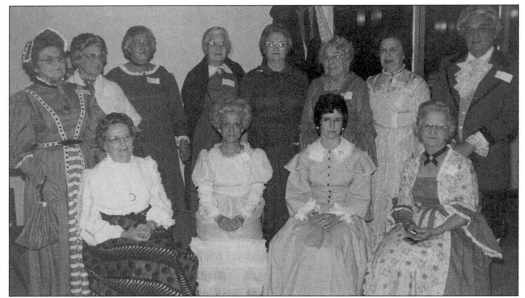

Cherokee County celebrated its sesqui-centennial (159th year of existence) in 1986. Many individuals and groups dressed in period clothing for the occasion. This group, which represents the many families that participated in the event, are, from left to right, as follows: (seated) Ann Jordan, Joan Hill Mann and Laura Upton Parker; (standing) Imogene Rains Whisenant, Olive Burkhalter Clayton, Estelle Smith, Mary George Jordan Waite, and Elwin Elliot.

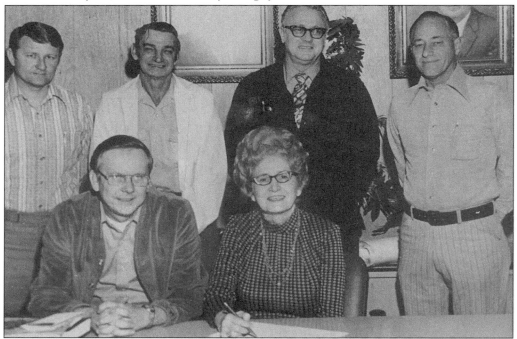

Harold Day, Hale Johnson, Burnie Bishop, Jeff Johnson, and Jack Fortenberry look on as Mayor Lillian White prepares to sign an official document. Lillian White was mayor of Centre for three terms.

Bob Minnix moved this log barn from the Stevens Farms at Woods Bend to his backyard. By doing this, he probably saved it from destruction, thus saving a bit of history. An early settler built the structure, which has one room and a hay loft. Mr. Minnix uses it to store and display the overflow of his collection of artifacts and antiques.

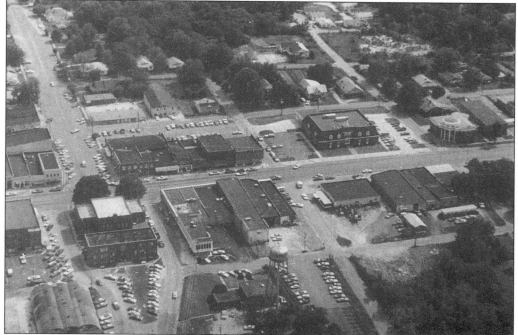

Today, Centre is a lively growing city with many businesses, churches, and schools as well as a thriving tourist industry. This aerial view shows part of the downtown area as it was in 1999. It has a very active city hall, tourist welcome center, and chamber of commerce, which are working to bring even more progress to the area.

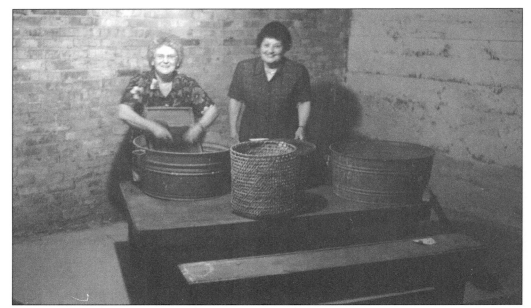

Frances Pollard and Erlene Harper demonstrate the way laundry was done by average country ladies (before electricity was available to rural areas) and by both country and city ladies who did not have a washing machine. This photograph was taken in the reproduction of an old-fashioned laundry room in the Cherokee County History Museum in downtown Centre.

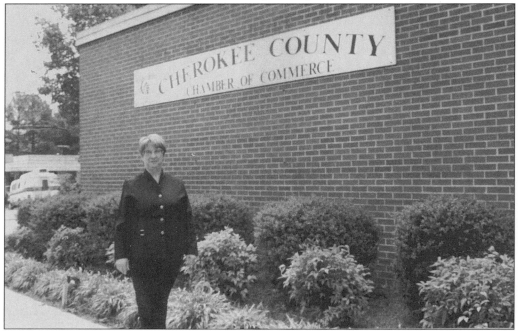

Mel Williams, director of the Cherokee County Chamber of Commerce and Welcome Center, stands outside the facility. She works to bring new businesses and tourists into the county. She is the one-woman staff of the chamber at this time and was very helpful in gathering data for this book.

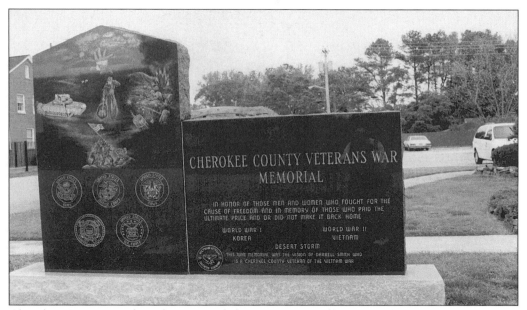

Cherokee County residents have served their country in all wars fought since its founding in 1836. This monument, the vision of Darrell Smith, honors the men and women who fought for the cause of freedom and then returned home, as well as those who gave their lives for their country. It salutes the deceased and the veterans of World War I, World War II, the Korean War, the Vietnam War, and Desert Storm. The monument is located in front of the city hall.

Deserted old houses can be found throughout the county, like this one located near Spring Garden. Many date back to much earlier times. Hopefully, the families that lived in them moved into better abodes and improved their standard of living. One thing is certain: each of the ruins once meant something to the family that built them.

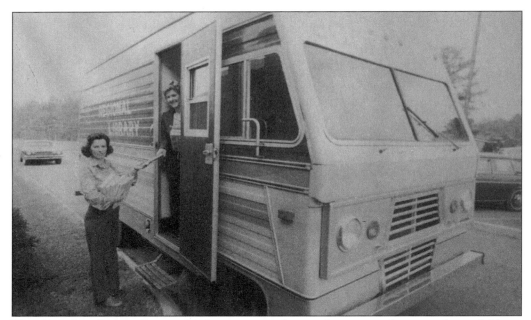

The Cherokee County Regional Library insures that reading materials are made available to those unable to travel to the library. Judy Helms and Reba Hardin are preparing the Bookmobile for its rounds.

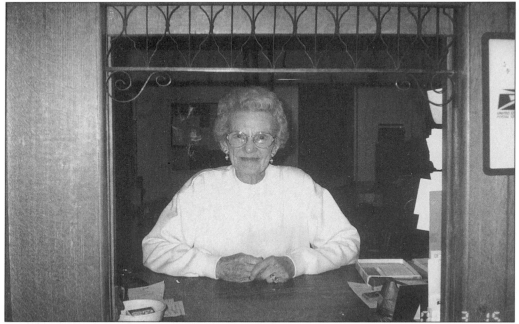

Cherokee County at one time had 114 post offices. This one at Spring Garden is the last of its kind. A new, more modern one is planned. Grace Salvage has been postmaster here for 45 years. She succeeded her father in this position. Mrs. Salvage knows her customers by name and gives each one a smile and good service. Although other post offices are sometimes nearer, many people travel to this one for their postal needs, as a tribute to Postmaster Grace Salvage.

Three

TRANSPORTATION FROM WATER UNTIL TODAY

When history books refer to settling the west, they were initially referring to what is now Northwest Georgia, Northern Alabama, and the areas north and west of these. The first settlers in what was to become Cherokee County used Conestoga wagons. Settlers brought all of their earthly possessions with them in these wagons. Tools, furniture, clothing, salt, basic foods, and livestock all were necessary. Oxen, mules, or horses were used to pull the wagons.

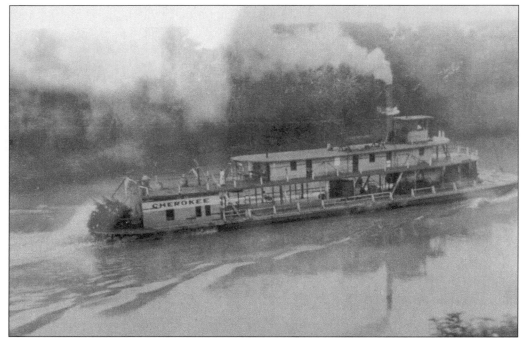

Riverboats traveling from Rome, GA, to Mobile Bay stopped in Cherokee County to pickup or deliver passengers, goods, and mail. The paddle wheelers *Cherokee* and *John J. Seay* were familiar sights to those who lived along the Coosa River. The Coosa River combines with the Tallapoosa River in Montgomery, AL, to form the Alabama River, which empties into the Gulf. This gave Cherokee County a broad market for its products.

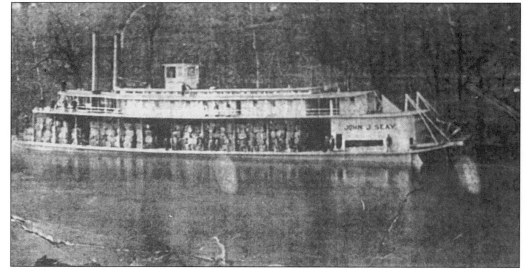

Steamboats on the Coosa River docked at Garrett's Ferry to load and unload their cargo. Passengers and locally produced items left Cherokee County destined for far away places; goods from all over the world were delivered to area stores. The *John J. Seay* burned and sank at Cedar Bluff with all cargo lost in 1888. When railroads were built in the area, riverboats were unable to compete with them and slowly faded away.

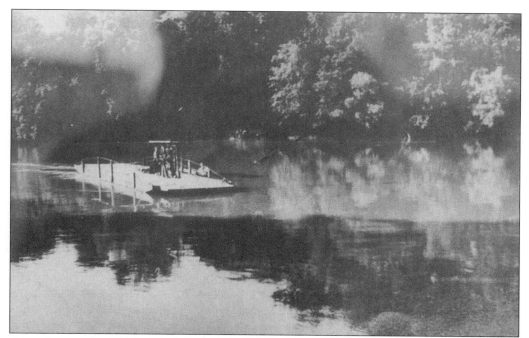

According to the W.W. Ward Company Surveyor Map dated September 1, 1917, 13 ferries operated in Cherokee County at that time. They were the Davis Ferry, Adams Ferry, Woods Ferry, Garrett Ferry, Trip Ferry, Ewing Ferry, Bradford Ferry, Lawrence Ferry, Hardwick Ferry, Sewell Ferry, McCoy Ferry, Pools Ferry, and Perkins Ferry. Ferries were eventually replaced with bridges.

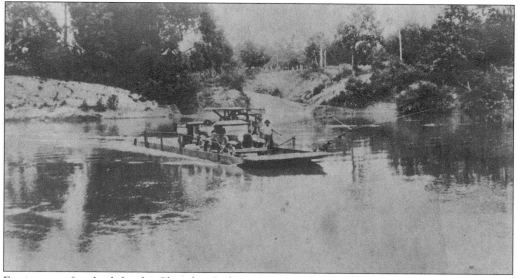

Ferries were first built by the Cherokee Indians. New residents took over the existing ferries and built more when the Cherokee were forced to leave. Ferries began operating in the county in the early 1800s, and some were still operating in the mid-1950s. At one time, 18 ferries operated here. Louis Keasler is shown ferrying a car across the river, in 1929. All manners of merchandise, vehicles, and people utilized the ferries.

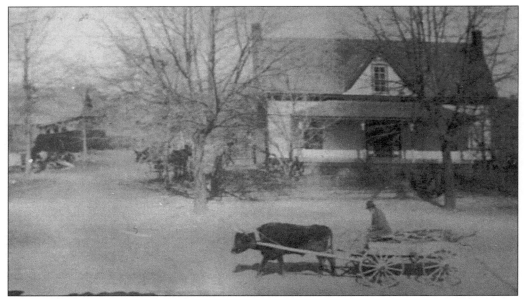

Dave McElrath passes the Johnson House in Centre with his ox-drawn wagon. Wards store is across the street and behind the photographer. Many different animals became known as oxen after they were castrated, like this steer. Oxen pulling wagons were a common sight throughout Cherokee County until the 1920s.

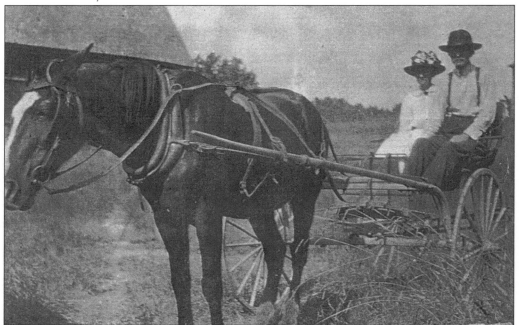

Wagons and buggies were widely used as transportation as late as the 1940s. Mr. and Mrs. Henry Donaldson are enjoying an outing in their two-wheeled buggy. Sarah Frances Stephens and Henry Donaldson were married January 6, 1876. They named their children William, Susan, Robert, Ida, Martha, James, Henry, and Nora. Mr. and Mrs. Donaldson are buried at Salem Cemetery in Bluffton.

Before the advent of automobiles most families were lucky if they had a buggy with something to pull it. However, some had fancy-frilled buggies with leather seats. This buggy is an excellent example of an upper-class buggy. Buster and Glenda Jenkins, along with their cat Jim, are pretending to go for a ride in the family buggy.

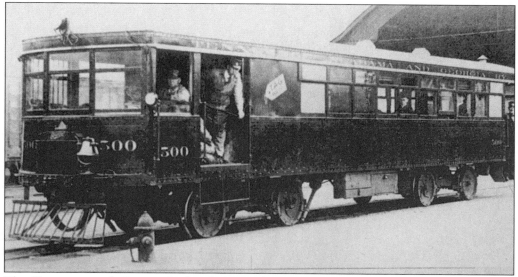

The Tennessee and Georgia Railroad operated a strange-looking machine on local runs in Cherokee County. It looked like a cross between a trolley and a European locomotive. Ewing, Blue Pond, Little River, Congo, Kinney, Loop, Taft, Blanche, Jamestown, and Chesterfield were all stops made by this vehicle, called the "Scooter."

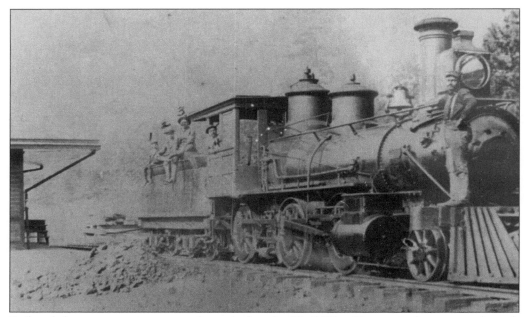

Railroads became a main source of travel after the Civil War. Two main lines came through Cherokee County. The northern line ran from Rome, GA, to Decatur, AL, with stops at Gaylesville and Cedar Bluff. Spur lines served other towns. The southern line was part of the national rail system and all points in the United States were available through it. This line made stops at Bluffton, Pleasant Gap, and Spring Garden.

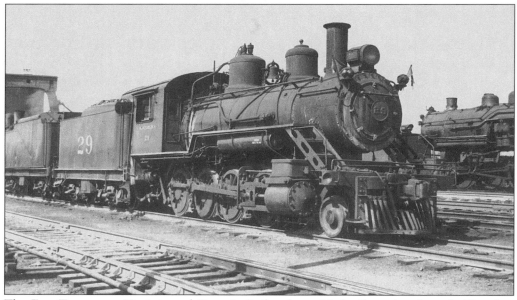

The East Tennessee, Virginia and Georgia Railroad provided rail service through Cherokee County. This line was later purchased by Southern Railroad. Steam engines owned the rails for decades. In the 1950s, diesel engines began to replace them. "Old 29" traveled through Cherokee County for many years and was one of the last steam engines to do so. Some people believe that the romantic era of railroading went with it.

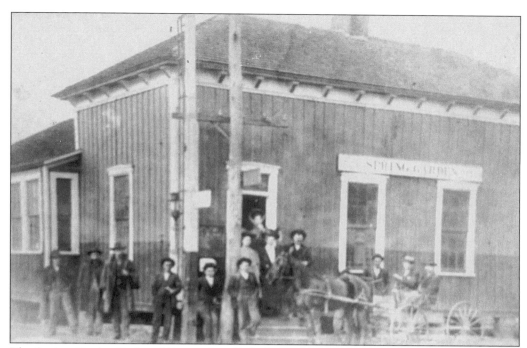

The Spring Garden Railroad Station handled a large volume of passengers and freight from the late 1800s until the mid-1900s. Here, people are waiting for the arrival of the train. John F. Parsons is in the wagon to the right. No one else has been identified.

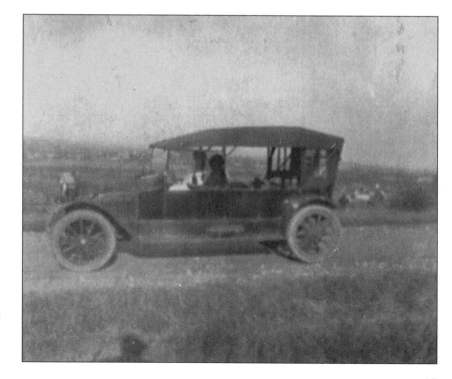

Mrs. Cardon and a friend are out for a ride in her new car. This was a luxury vehicle in its day, c. 1920.

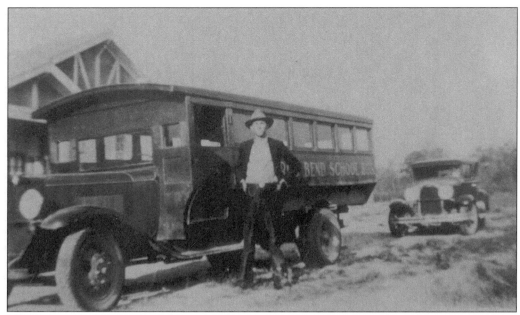

The importance of getting children to school was recognized early in Cherokee County. Many lived too great a distance to walk and no other means were available to them. As soon as it was feasible, school buses were purchased to fill the need. This early bus and driver helped solve the problem. The driver has not been identified.

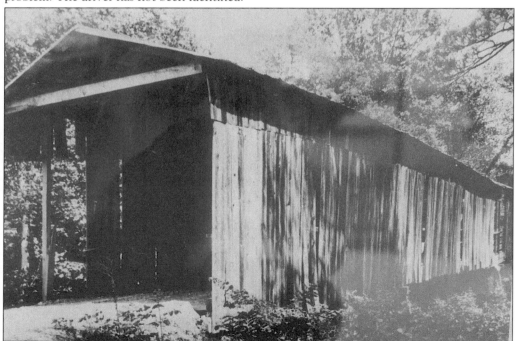

Many of the first bridges were covered bridges. This one was just upstream from Cobian's Mill and is a fine example of this type of bridge. Both the bridge and mill are now under the waters of Weiss Lake.

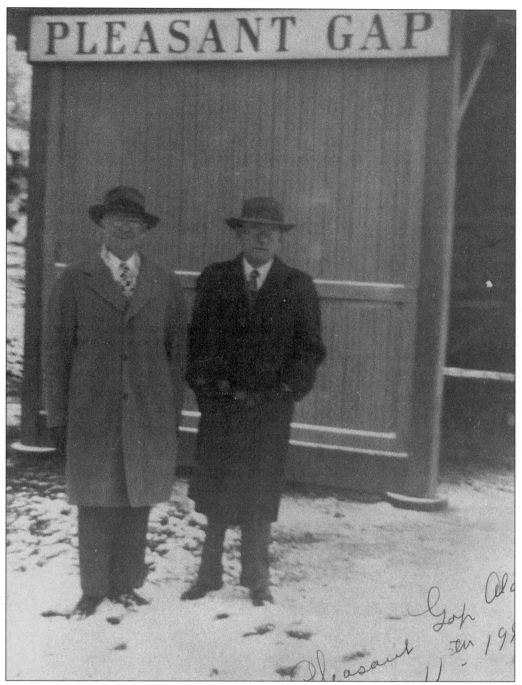

PLEASANT GAP

Pleasant Gap Station was a stop on the East Tennessee, Virginia and Georgia Railroad. Robert Braswell (left), who owned a cotton gin and a general store, and his friend wait for the train on Dec. 11, 1950. Notice there is only an overhead shelter, which does not protect from the cold. The snow on the ground was an unusual happening that early in the year.

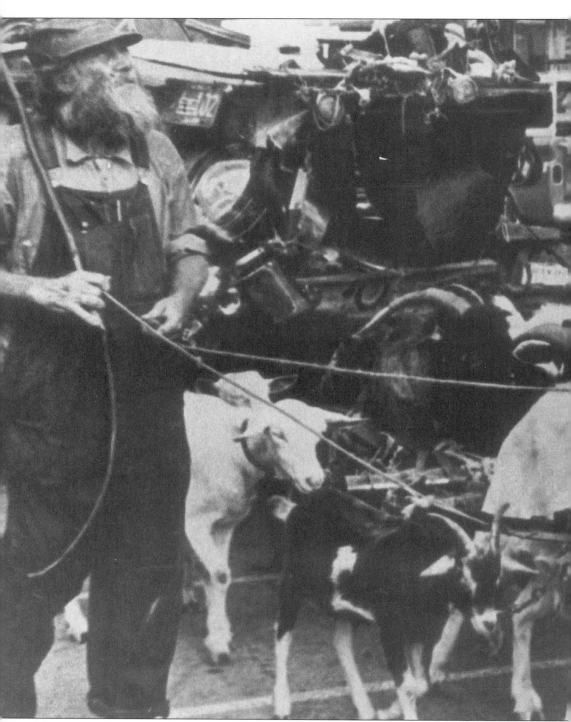

The Goat Man was well known in Cherokee County for many years. With his contingent of goats, he traveled throughout the United States. He passed through the county many times on his way home to South Georgia, and he sold souvenirs and signed autographs to cover the

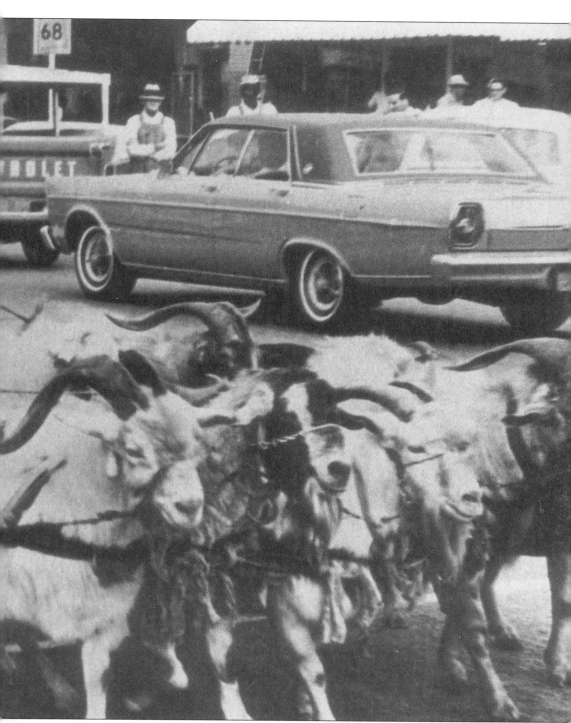

expenses of his travels. He and his goats are seen moving through downtown Centre. His goat-drawn wagon was indeed a unique form of travel.

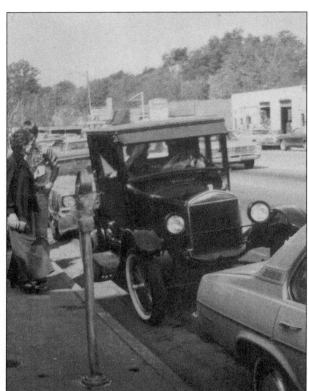

The fully restored antique car parked in downtown Centre is a 1920 Whippett. Few if any of this make of car are around today. The picture was taken c. 1960. Notice the parking meters; downtown parking was not always free.

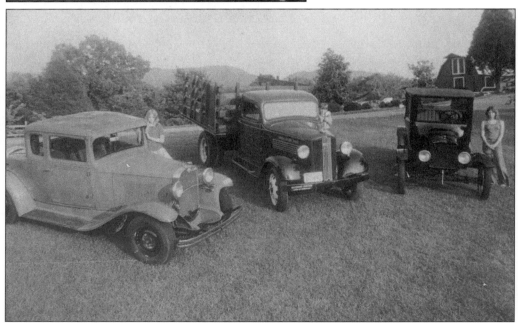

These three vehicles are fine examples of restored antique cars. Many individuals now restore and drive such vehicles. Caravans of them often travel great distances to be displayed at car shows. Glenda, Buster, and Teresa Jenkins are the individuals standing by the vehicles.

Four

CIVIL WAR EVENTS
IN CHEROKEE COUNTY

Lawyer Samual K. McSpadden came to
Centre in 1850. By 1856, he was
brigadier general of militia and in 1857,
he was elected state senator. When the
Civil War began, he joined the Army
of the Confederacy and was promoted
to colonel in October of 1862. As the
commander of the 19th Regiment,
Alabama Volunteers, he led them into
battle at Murfreeboro, Chickamauga,
Missionary Ridge, Dalton, and Resaca.
In 1865, he was elected chancellor, an
office he held until 1868. He then
practiced law in Centre.

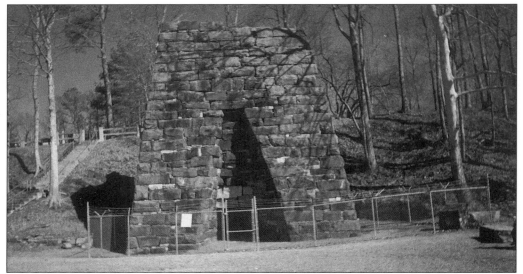

The Noble Brothers from Rome, GA, built the Cornwall Furnace in 1862–63 on the Coosa River. The furnace made pig iron, which was used to manufacture cannons and other war items for the Confederate Army. Thanks to the Cherokee County Historical Society, this is today one of the best-preserved furnaces in the south. A park allows visitors to picnic, reflect on history, and enjoy the scenery.

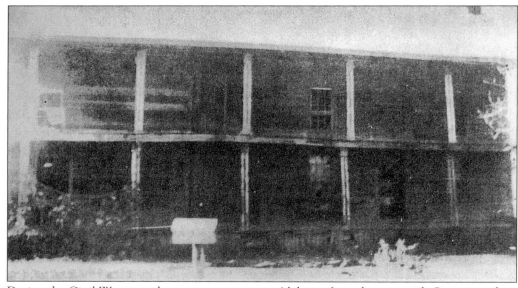

During the Civil War a northern army was sent to Alabama from the west with Georgia as their final objective. Expecting no resistance, they destroyed factories and plundered through Alabama until Col. Nathan Forrest began to pursue them. By the time they reached Gadsden, Forrest's smaller force had attacked them so many times that they left the wagons of stolen booty behind. Finally, they were tricked into surrendering. This house is where the surrender took place.

Cherokee County furnished 15 companies of infantry and two of cavalry to the Confederate States of America. Most either died in the war or chose not to return home after the war. Allen Millican was a member of Company I, 32th Regiment, Georgia Volunteers. He was wounded at the battle of Seven Pines. After the war he returned to Cherokee County, where he married Georgia Price in 1875 and served as county sheriff from 1896 until 1900.

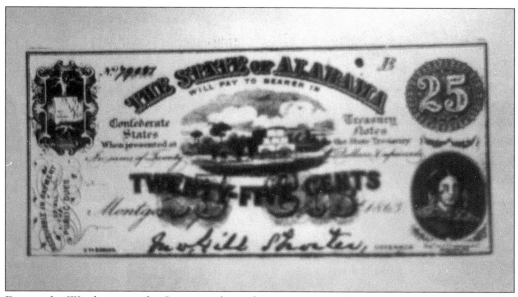

During the War between the States, each southern state printed treasury notes. Shown is a $25 note from the state of Alabama, dated 1863. These notes are collectors' items today.

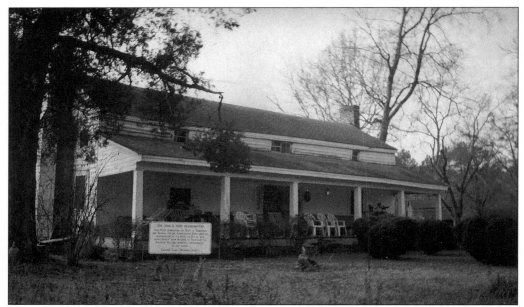

After their defeat in the Battles for Atlanta, the Confederate Army went west to Gadsden, AL, in an attempt to draw Sherman's army out of Georgia. From Gadsden, they went north in an attempt to join with another Confederate Army in western Tennessee. This house was where Confederate General Hood made his headquarters prior to moving further northwest.

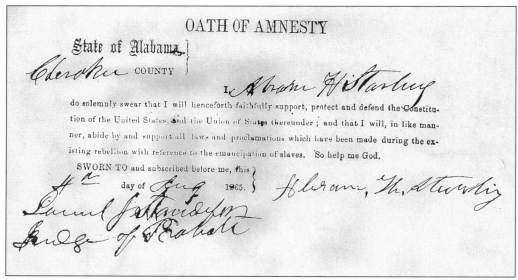

After the Civil War, former Confederate soldiers were required to sign an oath of allegiance to the United States. Many moved to California or to foreign countries rather than sign. Over 17,000 went to Brazil. The National Flag of the Confederacy still flies today over the Confederate Civil War Veterans Cemetery there.

Doctor Thomas White located and setup practice in Spring Garden in 1860. In 1863, he entered the Confederate Army as assistant surgeon of the 19th Alabama Cavalry. He filled that position until the end of the war. He returned to Spring Garden and resumed his medical practice in 1865. Doctor White was married and became a widower three times. He was a member of the Masonic Fraternity from 1865 until his death.

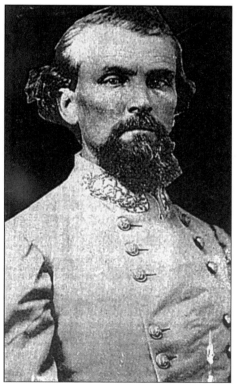

In 1863, Gen. Nathan Bedford Forrest tricked a much larger Union force into surrendering to him. This happened in Cherokee County near the Alabama/Georgia border. Forrest had his troops surround the Union camp and move back and forth very noisily. This gave the impression of a much larger force. Forrest invited the Union commander to a meeting and informed him that the Confederates had been reinforced. He told him to surrender or lose his command in battle.

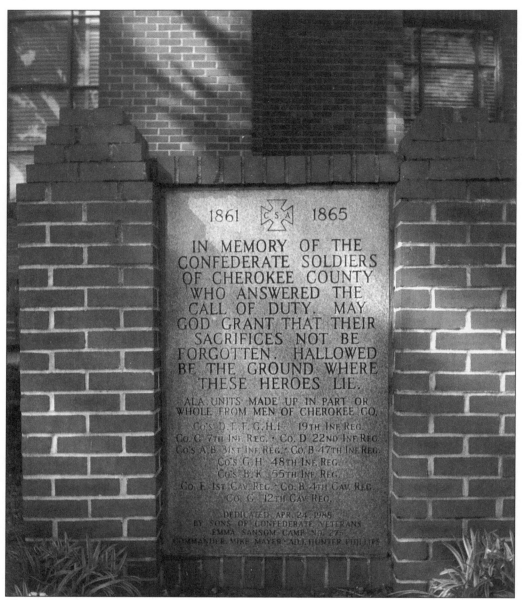

1861 ☩ CSA 1865

IN MEMORY OF THE
CONFEDERATE SOLDIERS
OF CHEROKEE COUNTY
WHO ANSWERED THE
CALL OF DUTY. MAY
GOD GRANT THAT THEIR
SACRIFICES NOT BE
FORGOTTEN. HALLOWED
BE THE GROUND WHERE
THESE HEROES LIE.

ALA. UNITS MADE UP IN PART OR
WHOLE FROM MEN OF CHEROKEE CO.
Co's D, E, F, G, H, I 19TH INF. REG.
Co. G 7TH INF. REG. • Co. D 22ND INF. REG.
Co's A, B 31ST INF. REG. • Co. B 47TH INF. REG.
Co's G, H 48TH INF. REG.
Co's B, K 55TH INF. REG.
Co. F 1ST CAV. REG. • Co. B 4TH CAV. REG.
Co. G 12TH CAV. REG.

DEDICATED APR. 24, 1988
BY SONS OF CONFEDERATE VETERANS
EMMA SANSOM CAMP No. 275
COMMANDER MIKE MAYER • ADJ. HUNTER PHILLIPS

This monument commemorates the brave men from Cherokee County who volunteered to defend the South from what they saw as a Northern invasion of their homeland. The Emma Sanson Camp No. 275, Sons of Confederate Veterans, placed it in 1988. Commander Mike Mayor and Adjutant Hunter Philips were camp officers at this time.

Five

FARMING: OLD
AND NEW METHODS

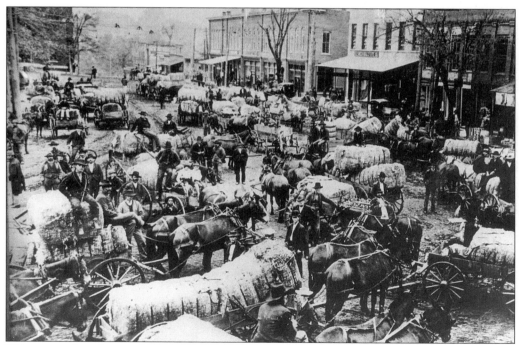

This scene, though not of Cherokee County, is representative of Cherokee towns when farmers brought their ginned and baled cotton to be sold to Cotton Brokers. The cotton was then shipped by riverboat to world markets. Cotton is and has been a major crop in Cherokee County since the late 1850s.

This unidentified driver and his oxen team are ready to accomplish their assigned task. Two bulls in double yolk indicate that their chore is probably a heavily loaded wagon. When castrated, bulls are called oxen. Oxen were used for many tasks, like pulling plows and mine cars, snaking logs, and towing wagons. They were used to do anything mules did.

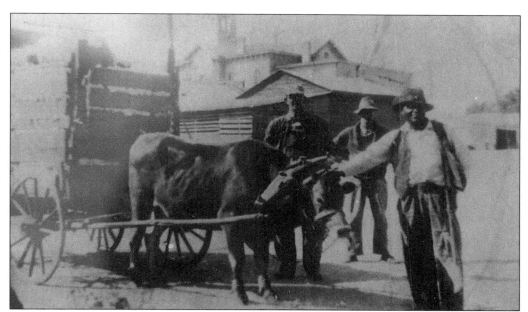

An ox pulling a wagonload of cotton to the gin waits by its driver. From left to right are C.E. Brannon, Sam Gouger, and Shell Covington. They are behind Jeff D. Jordan's store, which now houses the Cherokee County History Museum. The old courthouse tower is visible in the background.

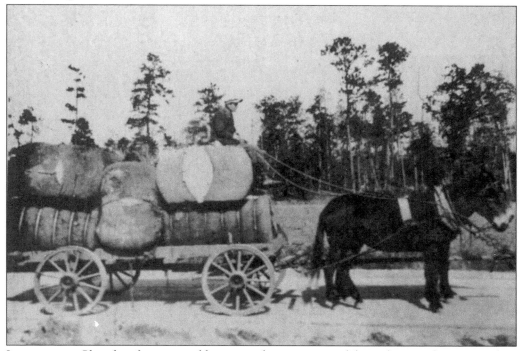

In past years, Cherokee farmers used horses, mules, or oxen to deliver their products to market. Here, two mules are pulling a wagon loaded with cotton bales. It looks as though this farmer had a good year.

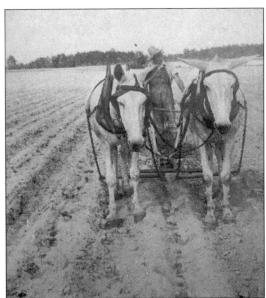

In this c. 1950 photograph, Wesley Smith plows cotton rows with Bill Ward's two white mules, which are a rare sight. Two together is even more unusual. The field is now a developed part of Centre where houses and businesses exist.

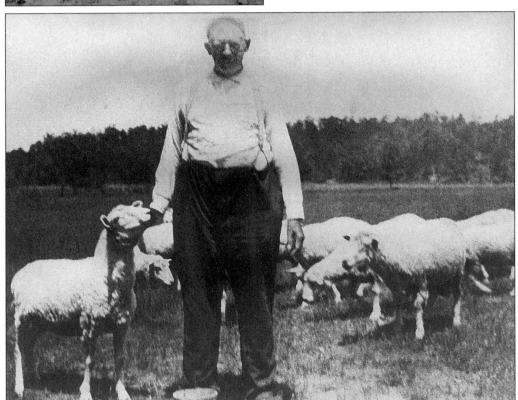

The first settlers raised sheep for meat as well as wool. Most houses had a spinning wheel used to make thread from wool. A loom was then used to make cloth from the thread. Sheep are still raised in Cherokee County but not as frequently as in earlier times. Mr. M.L. Braswell of Pleasant Gap is shown with his sheep, c. 1900.

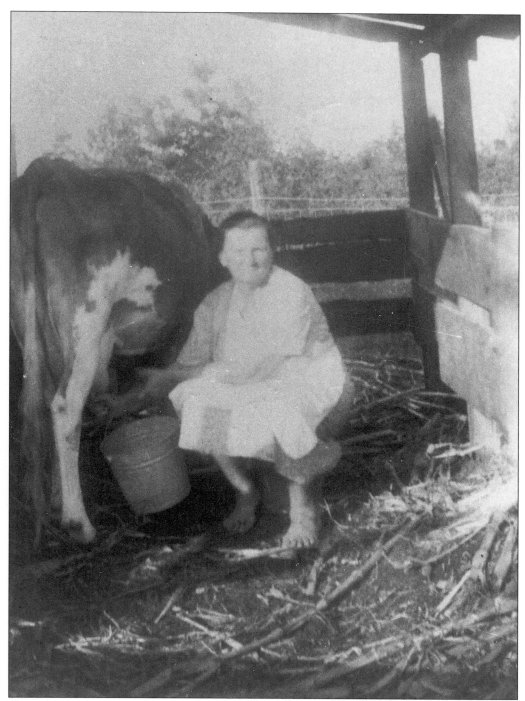

This lady is milking a cow the old fashion way—by hand. Milk straight from the cow had a different taste than today's processed milk. Many will agree that home-churned buttermilk with fresh cornbread was a great treat not to be forgotten. No store-bought buttermilk comes close to matching its taste.

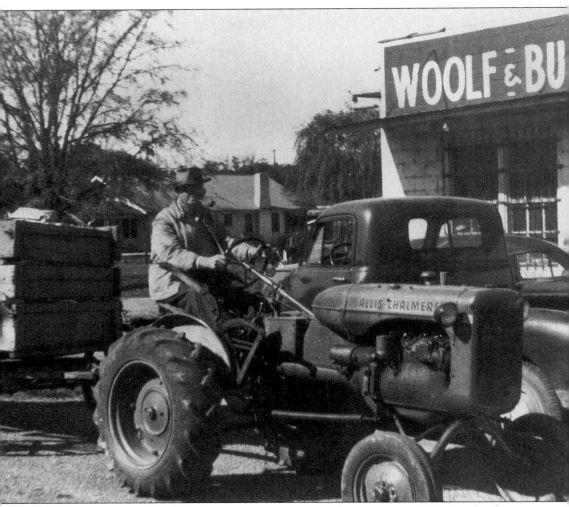

Ed Braswell is using his Allis Chambers tractor to pull his wagon, *c.* 1950. It is hard to guess what cargo he carries, because most anything could be loaded into this type of wagon.

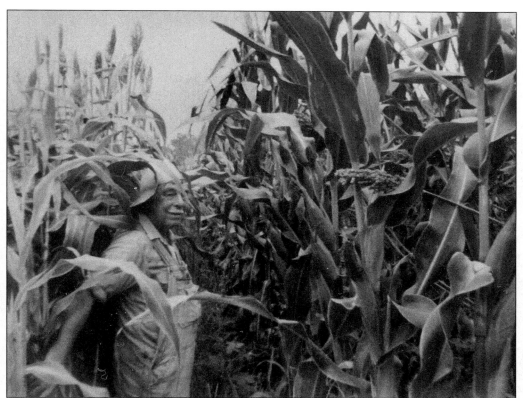

Bill Ward stands among his 10-foot tall corn and sorghum crop. His farm is just behind Main Street in downtown Centre. He, his wife, Ida, and their sons operate the farm. Two thousand acres of corn were planted in Cherokee County in 1998, with a yield of 65 bushels per acre. This totaled 182,000 bushels harvested. Mr. Ward said that this was a bad year because of a lack of rain.

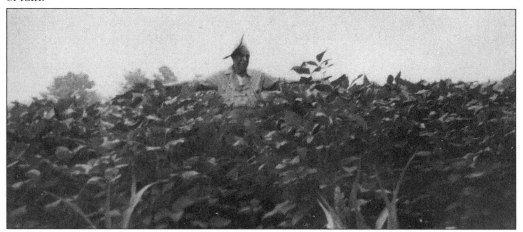

Bill Ward is stands in a field of his organically grown soybeans. It is evident that Mr. Ward and his family produce outstanding crops. His farm accomplishments are truly a treasure for Cherokee County. In 1988, 9,800 acres of soybeans were harvested in the county. The crop averaged 22 bushels per acre for a total of 215,600 bushels.

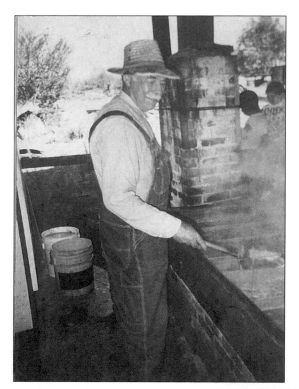

Bill Ward cooks syrup from liquid extracted from sorghum cane. Syrup makers once hauled their equipment from farm to farm, processing cane into syrup. At the age of 38, Mr. Ward swapped a cow for a syrup mill. He and his family have been brewing syrup in his backyard shed ever since. Mr. Ward and his sons grow sorghum for syrup and also process other farmers' cane.

Buster Jenkins demonstrates the operations of a hand pump, which is used to lift water from a well underneath. These pumps were work savers for those who had them. Most people still drew their water by means of a rope attached to a bucket, then passed over an overhead pulley and attached to a windlass. Turning the crank wound the rope around the windlass and raised the bucket.

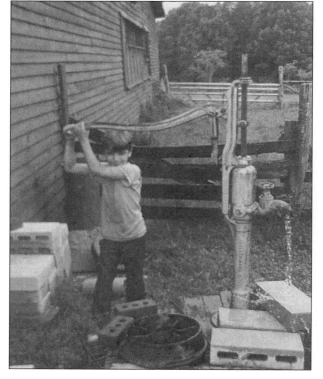

Many will remember this type of gasoline pump, *c. 1930*. Prior to electric pumps, these were commonly used at gas stations. In 1950, many farms still used these to service their equipment.

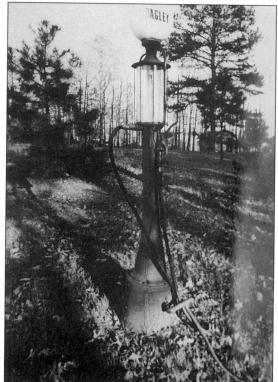

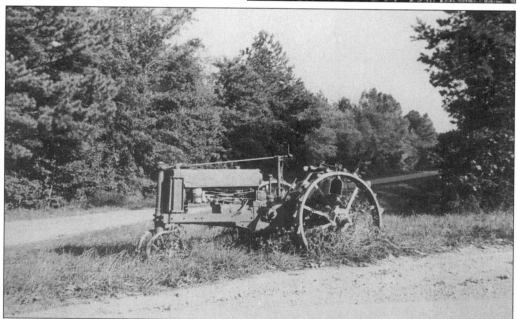

After many years of service, this tractor has been retired. Tractors have a long work life but do eventually wear out. This one makes an interesting conversation piece for people passing by. They speculate on its age, make, and what it was used for.

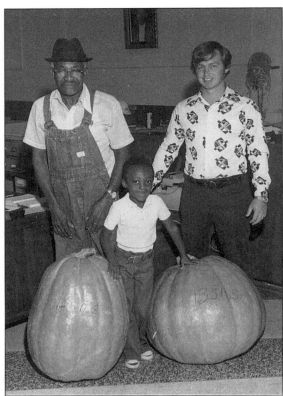

Pumpkins evidently grow to large sizes in Cherokee County. The one on the left weighs 125 pounds and was grown by Charlie Allen, shown with his grandson. The one on the right weights 135 pounds and was grown by Ronnie Roberts.

Will Ward and Lily Dickson, who were later married, are pictured worming a tobacco patch. At one time, tobacco was a big crop in Cherokee County. Hand-picking the worms off of the plants must have been slow and tedious work, but Mr. Ward and Miss Dickson seem to be enjoying themselves. Sometimes your work partner makes all the difference. Not long ago, farm families had many tasks like this that are handled today by machinery.

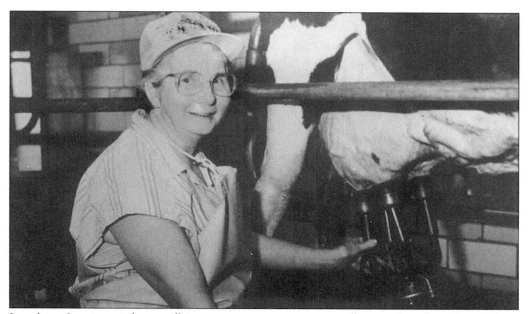

Josephine Jennings is busy milking a cow using a vacuum milkier on her dairy farm. These devices greatly ease the milking process. Multi-units allow one worker to milk several cows at the same time. This allows dairy farmers to draw their product much faster and is easier on the cows.

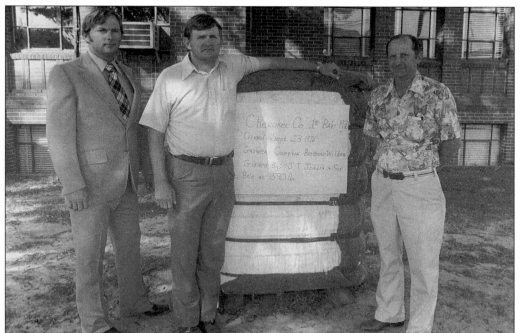

The first bale of cotton each fall is treated specially by placing it on public display. This is Cherokee County's first bale of 1976. The J.T. Jordan and Son Gin ginned it. George Harold Jordan is standing to the right. Tom and Derrick Compton grew the cotton and are on the left. The bale weighed 590 pounds.

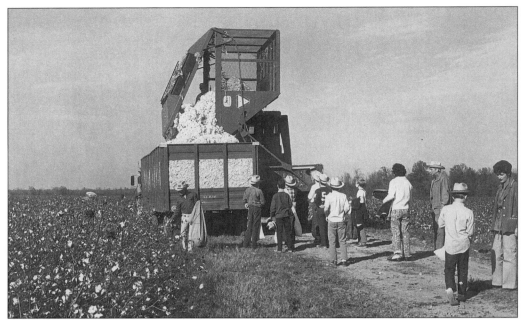

A modern mechanical cotton picker is dumping its load into a waiting wagon. Many residents of Cherokee County still remember the back wrenching pain from harvesting cotton by hand. Twenty seven thousand and two hundred bales of cotton were produced in the county in 1998. Due to the dry summer, this was a low yield year.

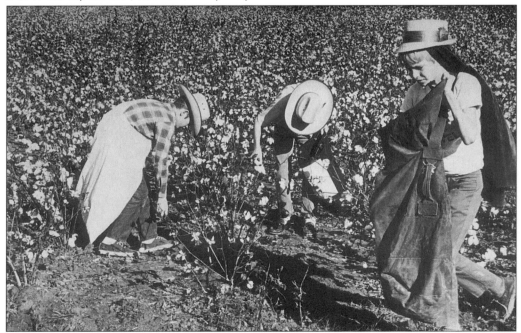

These unidentified boys are learning how cotton was once picked. From the photograph, it is apparent that these modern youngsters are not very well adapted to the work. This back-wrenching job was once a normal task for farmers, their wives, and children.

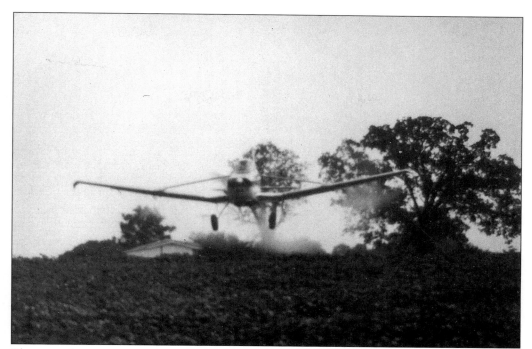

The most dangerous way to protect crops is to spray them from the air. Pilots of crop dusting aircraft must navigate near utility lines, trees, and other hazards and then fly just a few feet from the ground. There is no room for pilot error. Graham Tolbert of Cedar Bluff is one of these daring individuals. He began spraying crops in 1966.

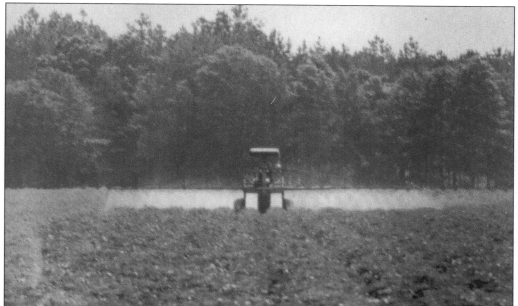

Without insect control most crops would be destroyed by pests. There are several methods of accomplishing this. They are organic gardening, ground spraying, crop dusting, and bug catchers. Here, a farmer protects his crop by using a tractor equipped with a sprayer.

Earl Gardner (left) and Stanley Anderson, agriculture teacher at Centre High School, inspect a beetle-infested pine tree. Beetle infestation is a major problem for pine trees.

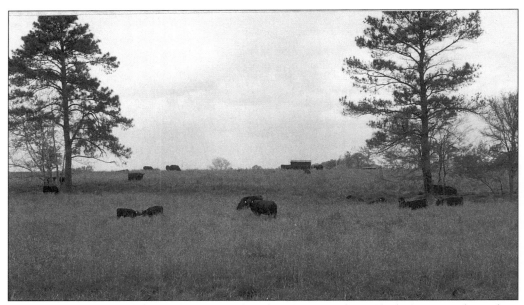

Raising beef cattle is a large enterprise in Cherokee County. These Black Angus are knee deep in grazing grass. They are pastured at Ellis Farm on H-411 East. Most who are successful in this venture maintain good pastures, as this farm obviously does. In January 1999, there were 16,500 head of cattle in the county. This number includes all the cattle and calves of both beef and milk cows.

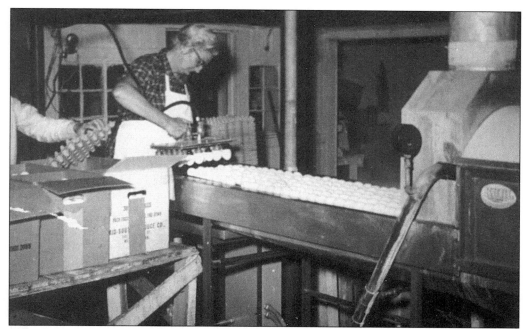

Egg production is big business in Cherokee County. Here, eggs are being processed and crated for market. Pictured is a modern method of accomplishing this. Not long ago, eggs were gathered, inspected with a light, graded, and packed totally by hand. Millions of eggs are produced in the county yearly.

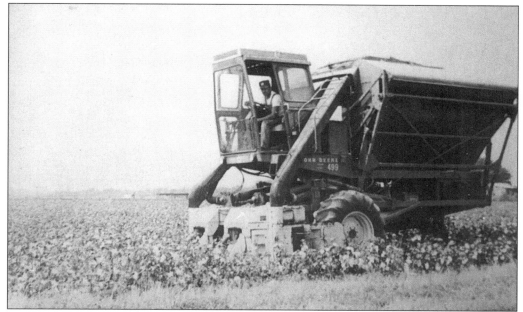

Modern harvesters make the job of gathering crops a much easier task. It is still a tiring job for the driver, who is often in the fields from the very early morning until nightfall. After a day driving this machine, most are in need of a good meal, a bath, and rest. They are aware that until the harvest is complete, the next day will be a repeat of the last.

Mr. Wilson is pictured with his moth catcher in a cotton field. Moths lay eggs on the plants, which hatch to be caterpillars. These eat the cotton plant. A moth catcher helps control the pests.

Paul Ward is going to spread fertilizer in a field. Fertilizing is necessary in order to get a good crop. The tractor and spreader that Mr. Ward is using makes the job a little easier.

Farmers use several different methods to irrigate their crops during dry seasons. Here a single nozzle but powerful sprinkler is being used to water a soybean crop. Soybeans are one of the major crops for farmers in Cherokee County today.

County Commissioner Sid Davis and another farmer inspect the soybean crop being loaded for market. The crop was less than normal this year because of a long dry summer.

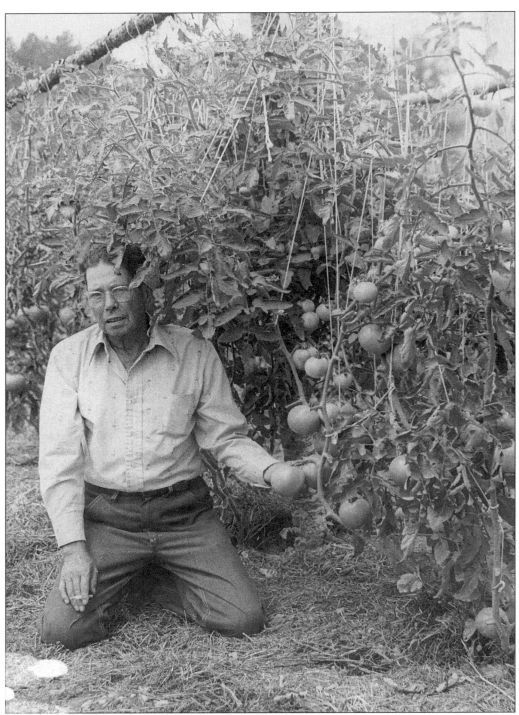

Many citizens, both town and county, have gardens and raise their own vegetables. Home canning is still popular and the majority agrees that these home-produced products have a better taste than store bought ones. Mr. Johnson is shown with his tomato patch.

Six

Churches
and Schools

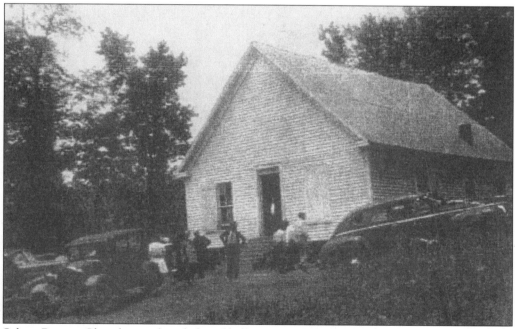

Salem Baptist Church was founded at Bluffton in 1854. The original wooden building was replaced in 1947 with a concrete block structure. This building was later brick veneered, at which time Sunday school rooms and restrooms were added. The church survived through Bluffton's boom period and its demise. Services are still held each Sunday and Wednesday. Throughout its existence, Salem has supported missions and other good causes.

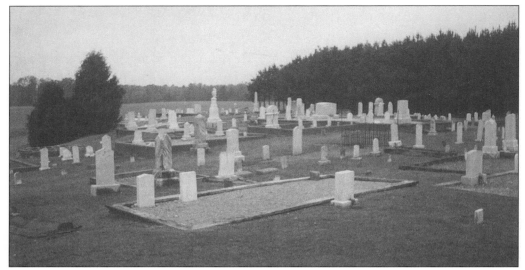

The Carmel Presbyterian Church was the first church built in the south section of Cherokee County. The original church was built of logs in 1835. Services are now held in a modern metal-structured church located across the road from the cemetery. Pictured is a small portion of the well-cared-for Carmel Cemetery. Most of the families that first settled in this area are buried here, and some of their descendants still live in the area.

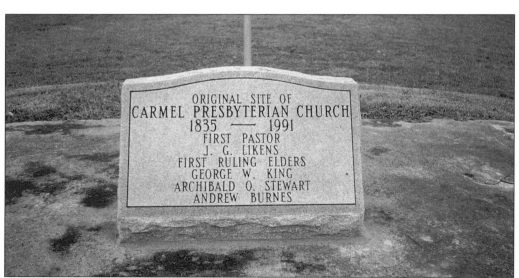

This marker in Carmel Presbyterian Cemetery honors its first pastor and ruling elders. It is located on the site of the original church. Billy Burn' s ancestors were among the first settlers in the area. He has done extensive research of the church's history, including photographs of three of the previous church buildings.

Pine Grove Baptist Church was founded in 1879. The M.D. Keener family, John Gray family, Bud Angle family, Wessley Field, and Sambo Wilson were charter members. This church currently has a membership of nearly 800 with Ricky E. Pollard as the pastor. The large beautiful brick church of today bears no resemblance to the original log cabin one. The oldest grave I located in the cemetery was dated 1888.

In his youth, Sam Jones worked as an ox cart driver in Cedar Bluff. Reportedly, at this time, he was a drunkard; however, he later became a well-known evangelist preacher. He traveled far and wide through Alabama and Georgia. He built a very unusual house that is now a museum in Cartersville, GA.

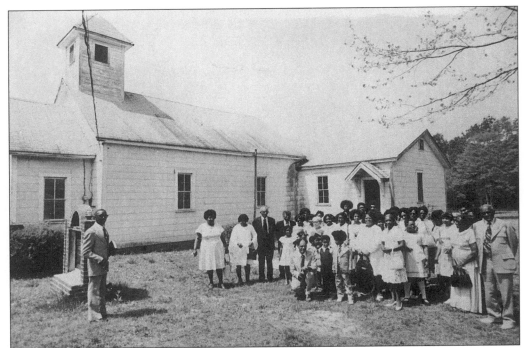

Saint Mary's Methodist Church has a long and honorable history. This is the church and its congregation, c. 1980. Rev. L.C. Marbury (left) was a circuit rider minister, meaning that he preached in more than one church and in more than one area. Wonette Brooks, R.C. Wright, R.L. Glover, and a Mrs. Southern are the only other individuals identified here.

Goshen Valley Baptist Church, located on the side of a hill just north of beautiful Goshen Valley, was organized October 28, 1973. Services began in 1974 and have continued ever since. Renovations were accomplished in 1989.

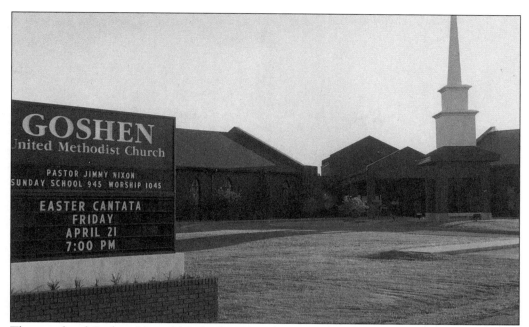

The people of Goshen United Methodist Church were called upon in a major test of faith in 1994. Twenty died and many others were injured when a tornado destroyed their church during services on Palm Sunday, 1994. The church has been rebuilt at a new location, just south of the old site. Its buildings are larger and the faith of its members remains strong.

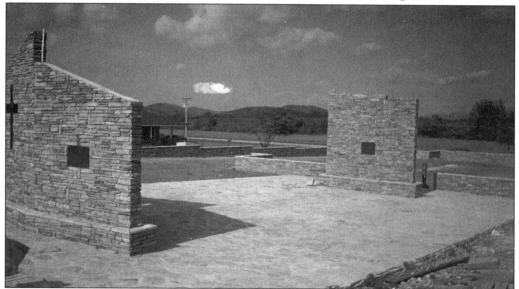

The members of Goshen United Methodist Church have built a memorial shrine to those who perished, those who were injured, and those who survived the tornado that destroyed their church. Plaques mounted on the monument describe the event. One plaque reads in part, "Those surviving gave remarkable stories of experiencing God's presence and sustaining power in the rescue efforts and through the hard days to come." Another lists all the names of those inside the church when the storm struck.

In the 1940s, Rock Run Baptist Church was a large wooden structure on a hill. Since then, a larger, more modern church has been constructed near the site of what had been Rock Run Furnace. It, like other churches, has increased its membership.

Noah Baptist Church is a good example of the display of faith in the rural community. It has advanced through time from a small wooden building to the modern brick building of today with an ever-growing membership. Tom Bridges is the current pastor. The oldest grave found in their cemetery was dated 1912.

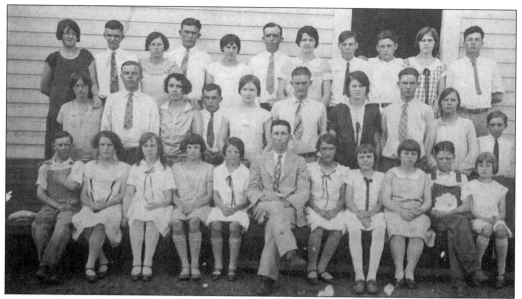

Many churches had singing schools. These Carmel Presbyterian Church school members are as follows, from left to right: (seated) R. Stewart, Clyde Stewart, Jennie Salvage, Grace Minton, Rosie Stewart, Audry Vine (teacher), Louise Stewart, Willie Mae Sanford, Catherine Savage, J. Naugher, and Catherine Ingram; (standing) Nellie Hinkle, H. Sanford, Gartrell Vanderford, J. Vanderford, Myrtle Ingram, Charlie Smith, Lectra Naugher, Frank Graham, Odis Sanford, Arnold Vanderford, Lucille Savage, Burnes Amberson, Vinice Minton, Dave Sandford, Cora Minton, Curtis Salvage, Flora Naugher, Hugh Minton, Robert Savage, Ruby Smith, and Odis Minton.

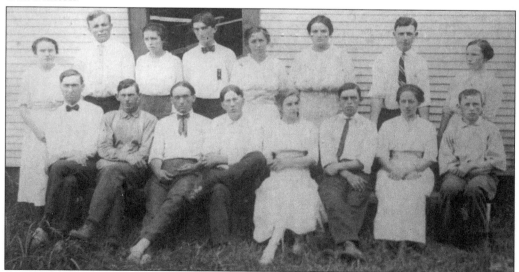

Those who attended Goshen Methodist Church Singing School were desirous of improving their vocal skills. The class of 1930 was, from left to right, as follows: (seated) Ernest McIntyre (teacher), Frank Stewart, Tollie Vaughn, Chest Davis, Ethel Parker, Ernie Stewart, Dela Anderson and Jim Stewart; (standing) Eula Parker, Fergurson Formby, Nettie Stewart, Westly West, Venice Anderson, Addie Kiser, Horace Ray, and Mary Savage.

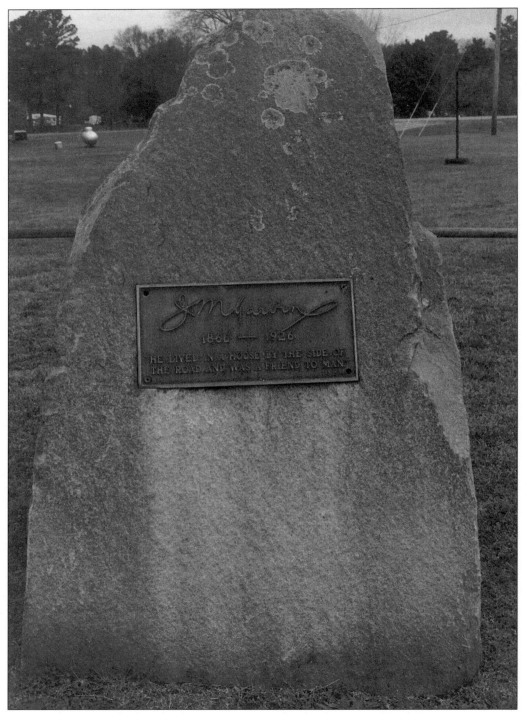

It is not clear as to whether this large stone is a marker for the town of Rock Run or a gravesite. The plaque reads "J. McGavin 1866–1926. He lived in a house by the side of the road and was a friend to man." The stone is protected by a metal bar fence around it.

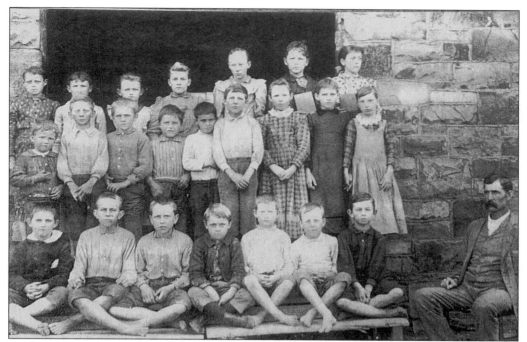

The Gaylesville Academy was one of the finest schools of its type in the country. The main building was constructed of stone in 1887. The following was extracted from a school pamphlet: "Gaylesville Academy stands for physical, mental, moral, and Christian education. Every effort will be made to develop character according to Scriptural ideals." The class of 1893 is shown.

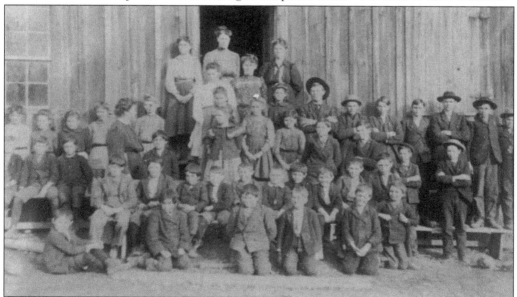

In 1900, Cherokee County had 108 schools in communities throughout the county. Goshen School in Goshen Valley was typical of early schools. Its student body of 1900 is pictured here. The only student identified is the girl in the very center; she later became Mrs. W.A. Ellis Sr. In 1884, a tornado killed 13 people in this area. Many of the students lost relatives in this storm.

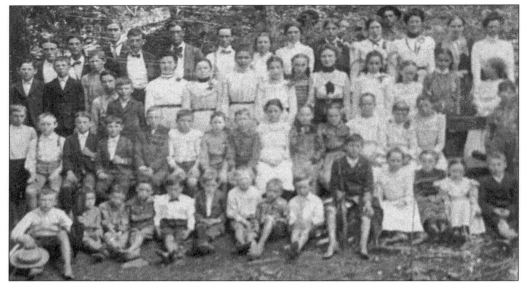

This is a photograph of Spring Garden School, *c.* 1900. Among those shown here are Fain Minton, John Smith, Elbert Westbrook, Lester Westbrook, Raleigh Rutherford, Dooley Tucker, Mabel Stephenson, ? Stephenson, Leah Westbrook Frances Tucker, Billy Phillips, Bess Sewell, ? Reed, Roy Williams, Andrew Tucker, Pronce Mitchel, Dan Sanford, Frank Sanford, Marion Gossett, Walter Swords. Luck Sanford, Alley Westbrook, May Sanford, Mary Pudgett, Greene Tucker, Mary Jones, Pearl Tucker, ? Reed, Pronce Mitchell, Marion Gossett, Alley Westbrook, and Greene Tucker.

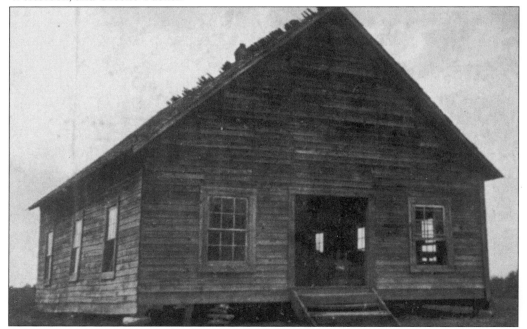

Tiller Colored School, located at Howell Cross Roads, was typical of rural schools in the early 1900s. Those attending these country schools were often the first in their family to receive any type of formal education.

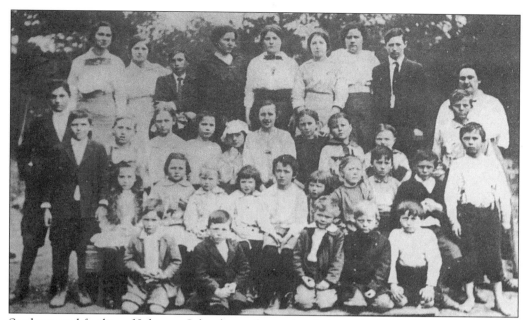

Students and facility of Johnson School pose for a school picture in 1915. Those identified are Cora Belle Fowler, Myrtle Bailey, Grady Fowler, Belle Sparks, Clara Fowler, Aulcia Sparks, Marvin Fowler, McWhorter Johnson, Joe Clayton, Elmer Sterling, Bernis Fowler, Edna Clayton, Faye Fowler, Edna Fowler, Lester Bobo, Bertha Blevins (teacher), McKinley Fowler, Miller Gallatt, Lewis Fowler, Tommy Brooks, and Wayland Gullate. Fletcher Clayton, Jennie Robertson, and Vester Brewer are also believed to be in the picture.

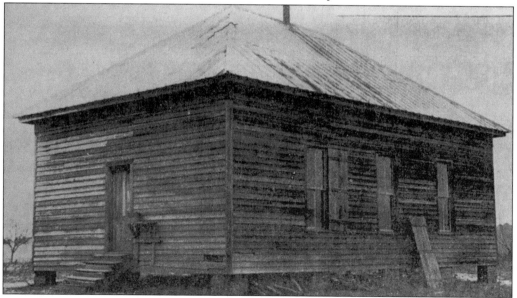

In the early 1900s, most country youth began their education in this type of school. Notice the stovepipe protruding from the roof. This vents the wood heater that warms the school in the winter. Woods Bend was a one room one teacher school, c. 1910. Students often had to walk for miles in order to attend school.

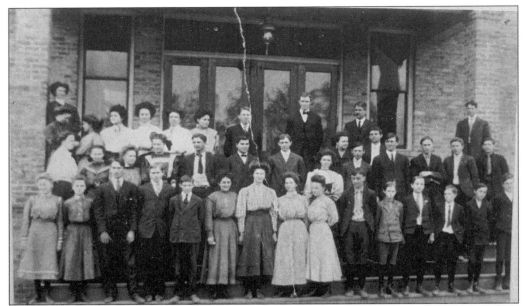

The is the student body and teacher of Cherokee High School in 1908. They are as follows, from left to right: (front row) all unidentified; (middle row) Lerabia Kennedy, Mary Tatum, Elizabeth Kennedy, Addie Mae Stone, Louis Johnson, Walter Leath, Frank Reese, Attie Johnson, Nettie Matthews, Briggs Tatum, and Arthur Reese; (top row) Lilly Reese, Fannie Sue Lawrence, Tevis Salvage, Ethel Morrison, Eunice DeJernette, Bonnie McCullough, Lulu Ward, John Stinson, Clarence Hately, Mr. L.M. Stevenson, and Jim Lockridge.

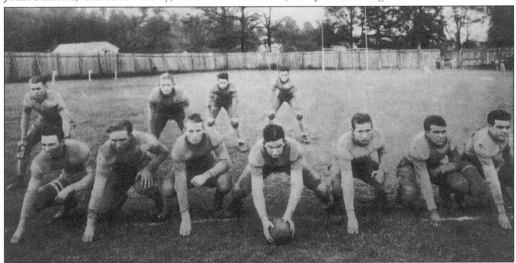

The 1931 Gaylesville High School championship football team had only seven points scored against them. On the line from left to right are Carlton Davis, Lewis Medlock, Homer Blackstone, Woodrow Chesnut, Malon Salman, R.C. Leath, and Woodrow Howell. The running backs are Arvil Saffolds, John Chesnut, Pat O'Brian, and Brandon Russell. Their schedule was Gaylesville 33, Jax Reserves 0; Gaylesville 19, Southside 0; Gaylesville 91, Gaston 0; Gaylesville 25, Geraldine 0; Gaylesville 19, Blountsville 0; Gaylesville 39, Rome, GA 7; Gaylesville 32, Glenco 0; and Gaylesville 52, Cedar Bluff 0.

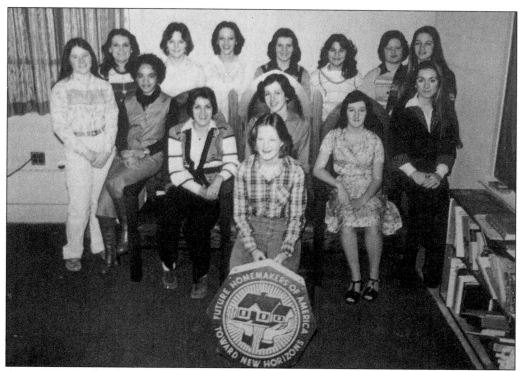

At one time, schools stressed home life for ladies more than they do today. Various home related skills were taught. These young ladies belonged to the Future Home Makers of America Club, c. 1965.

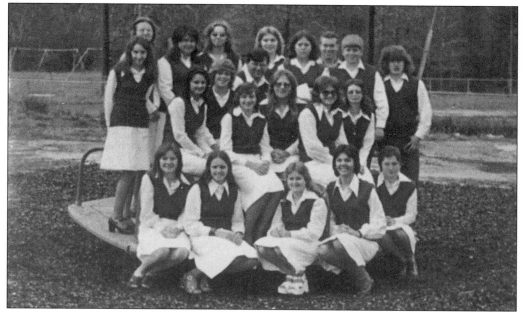

The Chorus of Cherokee County High School seem in a playful mood as they pose in the school playground, c. 1955.

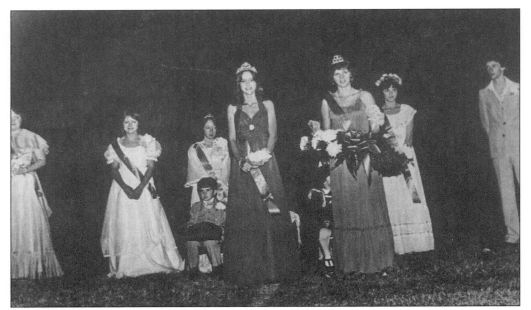

The members of the Gaylesville homecoming court of 1979 present themselves at halftime for the football game. They are, from left to right, Dewanda Ray, Ann Evans, Tammy Drake, Debbie Black (1978 homecoming queen), Mary Slayton (1979 queen), Robin Simpson, and Phillip Love (the queen's escort.) Windy Cooper, another member of the court, is not in the picture.

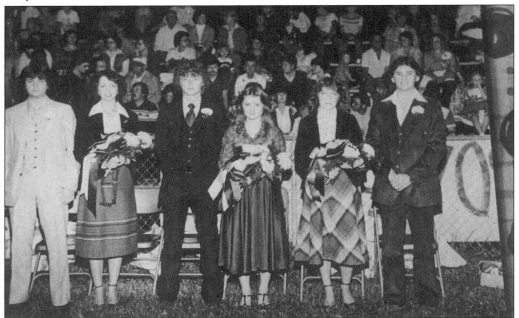

Sand Rock High School presents their queen, court, and escorts on September 28, 1997. The couple to the left are Queen Shari Vaughn escorted by Dale Wright. The center couple are Anita Campbell attended by Danny Alverson. The couple to the right are Rachel Parker attended by Wesley William.

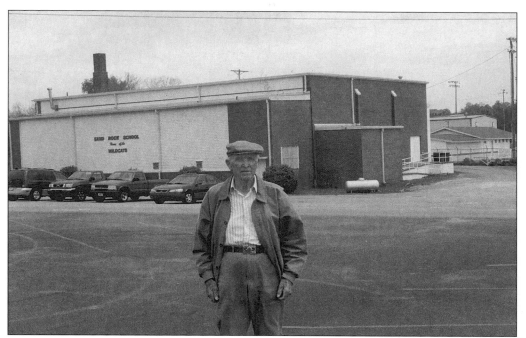

Mr. Melvin Parker, age 93, stands outside of Sand Rock High School. He was born in Sand Rock and has recently returned to the area. He attended school in a two-room wooden building approximately 100 yards from the current school. After graduating from college in Kentucky, Mr. Parker was a rural mail carrier for 37 years in Cherokee County. He was then promoted to postmaster at Round Mountain.

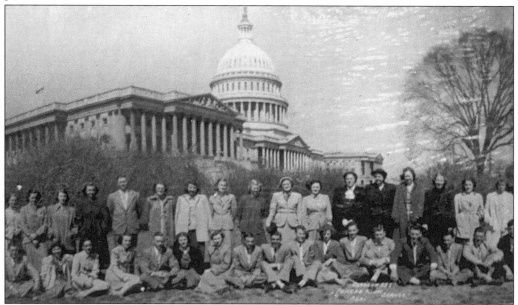

The Centre High School Senior Class went to Washington, D.C. on a class trip. Here they are with the Capital Building in the background. Traditionally, the senior class of many high schools take a trip to the destination of their choice.

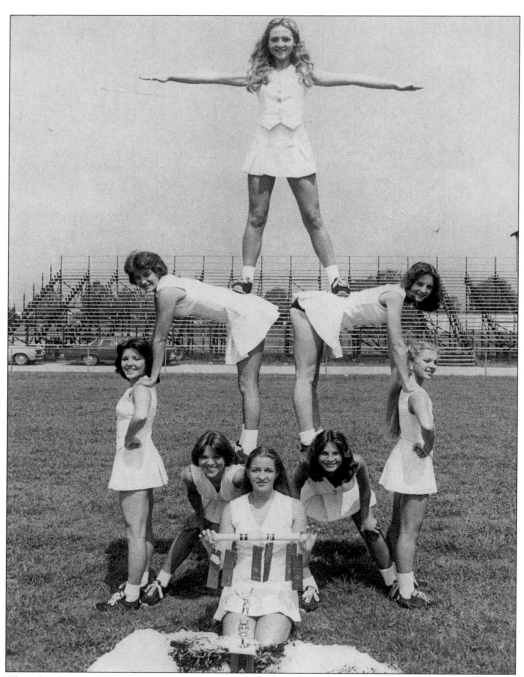

Cheerleaders today perform as circus quality acrobats. These ladies of the 1980 Centre High School cheerleading squad have proven their ability; notice the trophy and spirit stick with excellent and superior ribbons. Kneeling is Lori Oxford. Jennie Perry (married name) and Kay Bandini have their hands on their knees. Standing are Lynn Arnold and Susan Smith (married name). Standing on Perry's and Bandini's backs are Darlene Singleton and Sonja Hale. Lisa Vaughn stands on top of the others.

Seven
FAMILIES OF
CHEROKEE COUNTY

Mary Elizabeth Frost Clonts was the daughter of Dr. Eli Frost, both of whom are buried at Salem Church Cemetery. Mrs. Frost was born November 8, 1842, and died September 29, 1923. Her children are shown standing behind her. They are, from left to right, Robert, Benjamin, Ella Mae, Homer, and Presley. Her husband and father of her children, William Presley Clonts, preceded her in death. He is buried at Rock Run Cemetery.

Samuel James Burns was born at Spring Garden on July 27, 1847, and lived his entire life there. Mr. Burns and Mary Graham were married August 5, 1875. He owned a livery stable and boardinghouse in Spring Gardens. Although he became financially secure, it was said that he never forgot his friends.

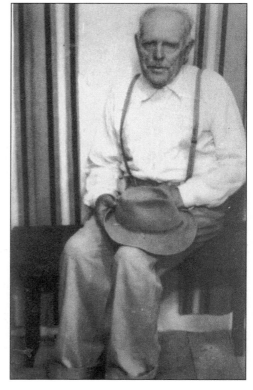

Landrum Bramlett lived at New Moon. He was born in 1850 and lived to be 100 years old. During his life, he saw and did many things, but his biggest claim to fame was his stint as a rider on the Pony Express. He delivered the mail from station to station on horseback during the late 1800s.

W.W. Ward was Cherokee County surveyor for 40 years. He surveyed Cherokee County in 1917, and his map, dated September 1, 1917, shows 76 towns, 3 rivers, and 13 ferries in the county. Ward was a member of Dawes Commision, which surveyed the Oklahoma Territory.

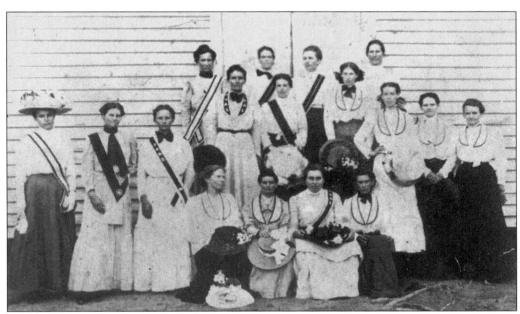

The ladies of Rebecca Lodge pose outside their lodge at Rock Run in 1930. Rebecca Lodges are the lady members of Masonic Lodges.

Martha Elizabeth "Lizzie" Donaldson and Presley Clonts are pictured on their wedding day. She was born at Tecumseh on September 12, 1888, and died May 4, 1966. He was born August 9, 1884, and died November 24, 1952. They are buried at Salem Church Cemetery.

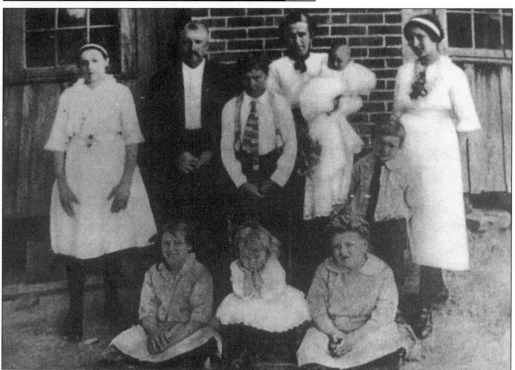

This c. 1915 photograph captured the following, from left to right: (seated) Bessie Ida, Lula Don, and Grace Estelle; (standing) Mattie Esmer, Hugh Alford, Robert Oscar, and Louanza ? (holding an unidentified baby). The last name of the family is unknown, and the young boy and lady standing to the far right remain unidentified.

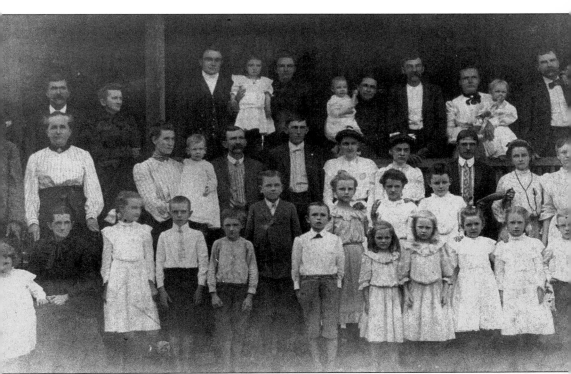

The original family name of these individuals is unclear. The following names are listed as they were written on the photograph (most last names were not listed): Aunt Emma, P.M. (in arms), Uncle Pink, Aunt Marshall, Fred (in arms), Joe Wheeler, Uncle Owh, Aunt Lou, Mom, Ed (in arms), Papa, Joe Stewart, Louella, Minnie, John Roberts, Stella R., Ethel, Aunt Flo, P.W. (in arms), Uncle Pace, R. Naugher, Grandma, Leola, Aunt Mary, Noles, Claude, Joe R., Norris R., Ed R., Eliah R., Nora R., Exa R., Myrtle, Currie R., Jessie, Essie, and Leroy.

Sam C. Ward worked with TVA in 1938. He was a flight commander during World War II and instructed pilot training of women in the Army Air Corps. In 1947, Mr. Ward became part owner of a molding sand plant at Camder, TN, and worked with Southern Refractories making ladels and furnaces used in making steel.

Dr. Franklin P. Ward attended dental school at Vanderbilt University. He then set up practice in Cherokee County. He built a fishing boat and loved to use it. McElrath Mill Pond was his favorite fishing area.

Pvt. J.L. Battson was in the Signal Corps during World War I. In 1917, he departed Centre, AL, in charge of recruits on the way to France.

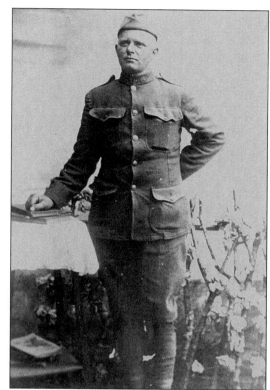

Archie Duncan of Sand Rock was captured during the Battle of the Bulge in World War II. He spent six months as a POW in Germany but was released shortly before the end of the war. He and his wife of 52 years, Betty, live at Sand Rock. They are the parents of Ronnie Duncan and Patricia Ann Hood.

After graduating from Jacksonville State College in 1967, Emily Ward attended Virginia Intermont College and trained as a missionary journeyman. She was picked by the Southern Baptist Mission Board for this training. Miss Ward then went to Brazil, where she taught children of missionaries. She now works as bookkeeper for Jordan Cotton Gin.

As late as the early 1900s, young boys were clothed in dresses and girl slippers. Although the identity of this boy is known, his name is purposely not mentioned. He represents all boys his age during this era.

Stacy Kelly and Amy Allen were the Cherokee County preschool king and queen in 1980.

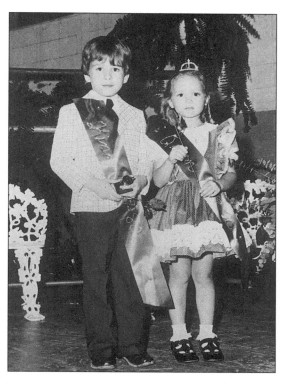

Renee Abernathy proudly wears the banner declaring her the 1979–80 queen of Cherokee County Junior High School.

Teresa Pierce was the 1979–80 queen of Cherokee County High School. It is tradition for many schools to elect a queen for each school year.

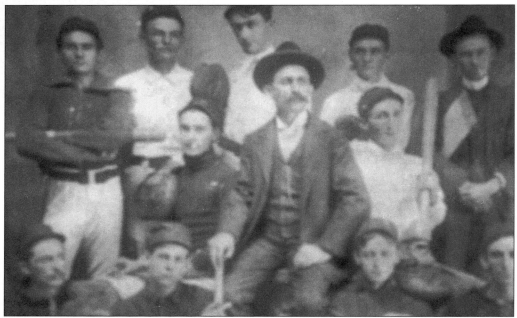

Organized baseball has been played in Cherokee County since the 1880s. The owners of iron ore furnaces recognized their employees' need for an outlet from their daily work routine. They formed teams from their workers and organized a league. The members of this early team are not identified.

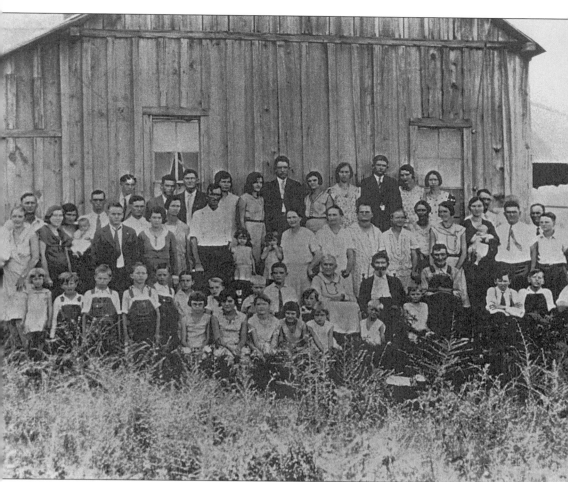

Family reunions are always a special time. They give each family member a chance to talk with those not often seen and meet with new members of the family by marriage or birth. I was unable to identify this family but was assured by its donor that it was a Cherokee County family.

Alice Robershaw Smith Hudgins was the daughter-in-law of Milton Smith, one of the early settlers of what later became Bluffton. Alice Smith was the wife of William A. Smith and the mother of Minnie, Robert, Elizabeth, Frances, Charlie, Annie, James, Essie, Bessie, and William. She married Bose Huggins after the death of her first husband.

William (Bill) Smith was the youngest son of William and Alice Smith. He was born in 1909 and raised his family in Bluffton. He and his wife, Alma, had five children. Their children were the last of an original settler's family to be raised in Bluffton. The children's great-grandfather, Melton Smith, settled there in the 1850s. Salem Baptist Church and Bill Smith's home are all that is left of the town of Bluffton.

Josephine Nolan and Ann Jordan pose in the Jordan Home. They are from a well-known and respected family in Cherokee County. Ann Jordan is actively involved with many civic projects.

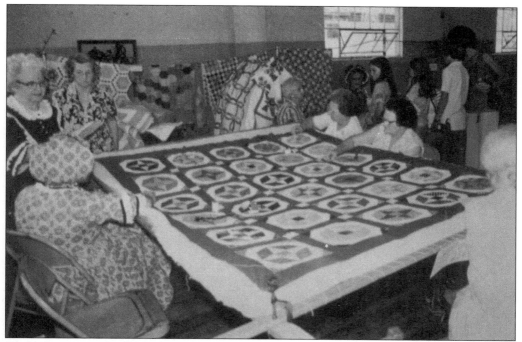

Settlers' wives originally made quilts to keep their families warm during the winter. They were made from scraps left over from other works. Several ladies would gather at one house, talk, and sew the rags into beautifully designed bed covers. The tradition still thrives today. Ladies meet, talk, and make quilts that are sold to raise money for various causes.

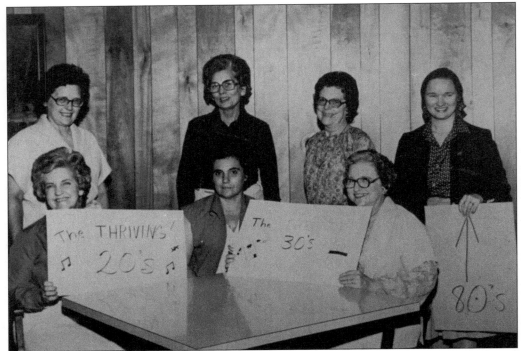

These ladies represent three decades: the Roaring Twenties, the Depression of the 1930s, and the upbeat 1980s. This was a part of Centre's sesqui-centennial celebration. Riba Hardin sits with the 20s decade sign, while Ann Shoemaker holds the 80s decade sign. The rest of the ladies are unidentified.

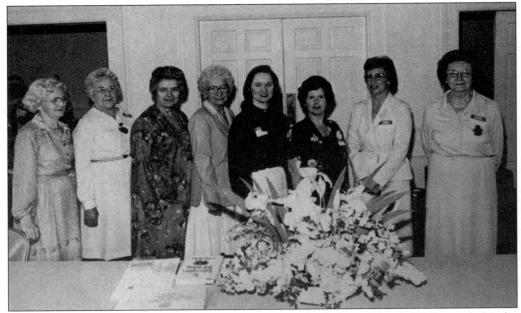

There are several ladies' clubs in Cherokee County. The ladies of the AFWC pose behind a beautiful centerpiece. The only one identified is Ann Shoemaker in the center.

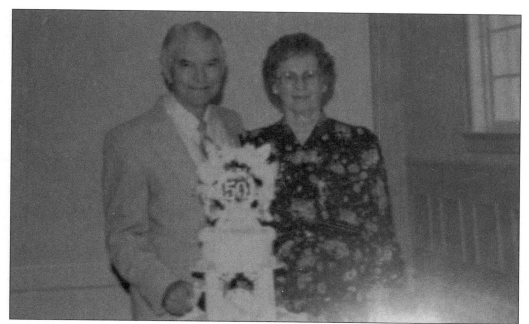

Earl Gardner and his lifelong partner, Evelyn, celebrate their 50th wedding anniversary. Every wedding anniversary is special, and a 50th is even more so. In this day and time, it is a rare occasion.

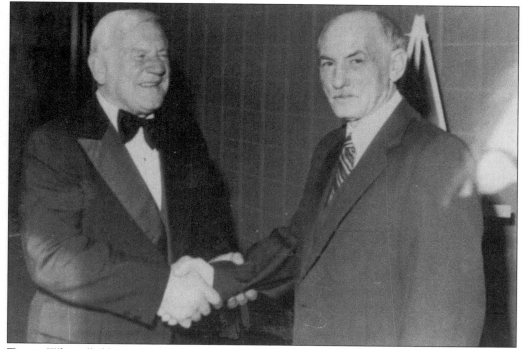

Tarzan White (left) was an All-American football player at the University of Alabama in 1935. He became a professional wrestler and a world champion in the sport. Mr. White is a member of the Alabama Sports Hall of Fame. He later became a mail carrier at Jamestown.

Brigadier General (Judge) Lumpkin retired from the USAF as assistant judge adjutant. He was head of a panel formed by the governor of Alabama to restructure the court systems of Alabama. He served as district judge for approximate 17 years. Judge Lumpkin and his wife, Spergeon, live in the house built by his grandfather, Samual K. McSpadden, in the 1850s.

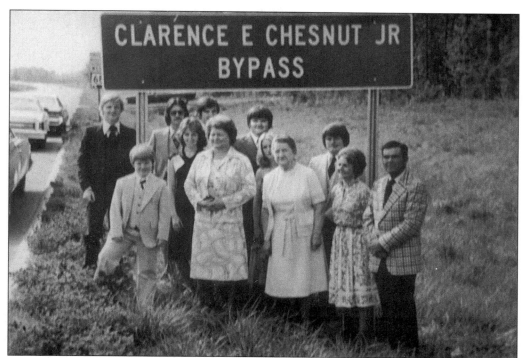

Clarance E. Chesnut Jr. was a well-known businessman and a respected member of Cherokee County. The bypass around Centre was named to honor him. The Chesnut family are shown during the opening ceremony of the bypass.

Mary George Waite was president of Farmers Merchant Bank and the first woman president of the Alabama Banking Association. She is making a presentation to E.E. Davis.

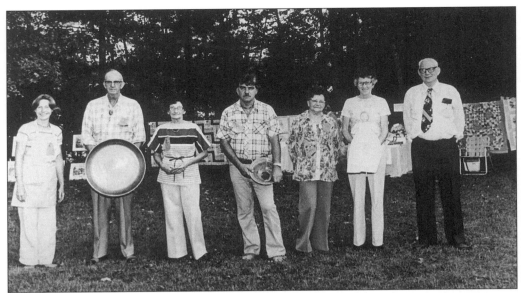

Kristine Thoones, John Stephens, Mary Ruth Longstreet, John Kent Baker, Irene Tallent, Jessie Ridgeway, and Clark Watts were winners at a craft show in 1980. Southerners are known for being talented with their hands and mind. Shown in this book are but a few of the many talented people in Cherokee County.

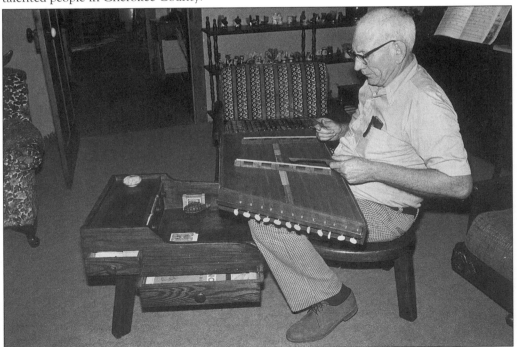

Clark Cody Watts is playing the dulcimer, which he hand-made. Mr. Watts also made and repaired clocks. He made a clock for each member of his family. He was a bugler with the Army Air Corps during World War II. He later played with several bands and was proficient with many different instruments.

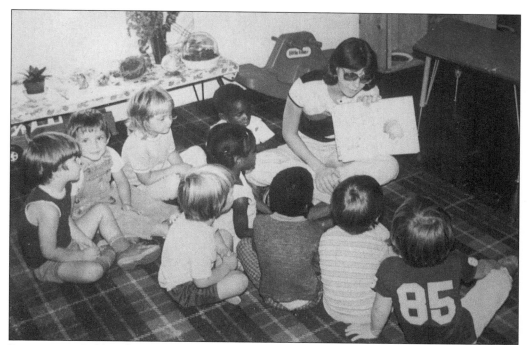

Beginning a child's education early is recognized as a key element in their later advancement. Here, Judy Richardson teaches a preschool class. Notice she has the attention of all but one member of the group, an impressive feat with children of this age.

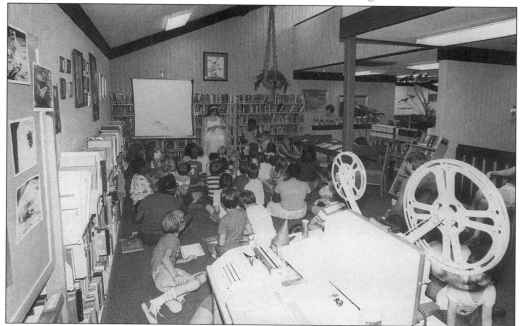

Story-telling is a special art that has been around for thousands of years. The Cherokee Indians used story-telling as a method of remembering their history. The Cherokee County Public Library is shown during a story-telling event.

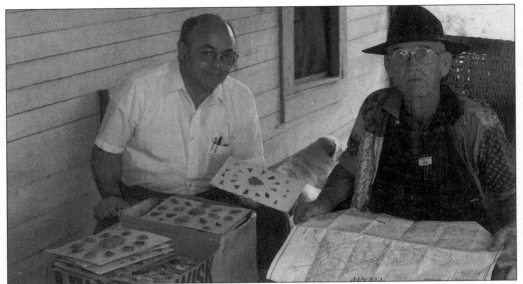

Bob Embry (right) shows Bob Minnix his collection of Native-American artifacts. Native Americans lived in this area for over 9,000 years. Many nations evolved during this time and, therefore, many related items are found here. Relic hunters are numerous today, and many have fine collections.

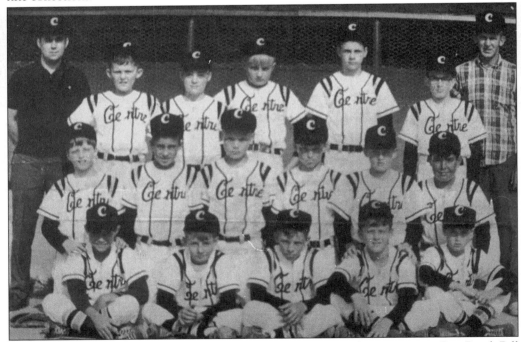

Baseball continues to grow in popularity yearly. Steve Barrett, Johnny Neyman, Ray Reed, Bill O'Neal, Mickey Kisor, Rickey Treece, Bobby D. Abernathy, Alvin Lewis, Johnny Proctor, Joey Hampton, Ronnie Davis, Kenny Gossett (manager), Mike Boatfield, Andy Ward, Tim Garner, Randall Wigley, Chip Henderon, and Leon Gossett (manager) are the host team in a Dixie Youth League tournament.

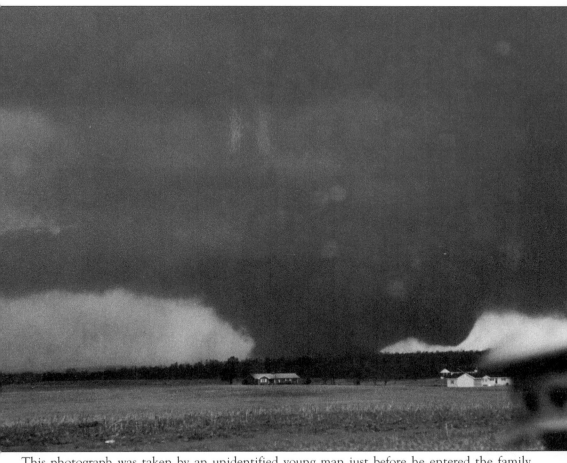

This photograph was taken by an unidentified young man just before he entered the family storm shelter. This 1994 tornado was a category four storm reported to be a half mile wide. It destroyed Goshen Church, killing 20 and injuring many others. It also damaged or destroyed several homes in the Rock Run area. This same storm cell continued into Georgia and killed 13 there.

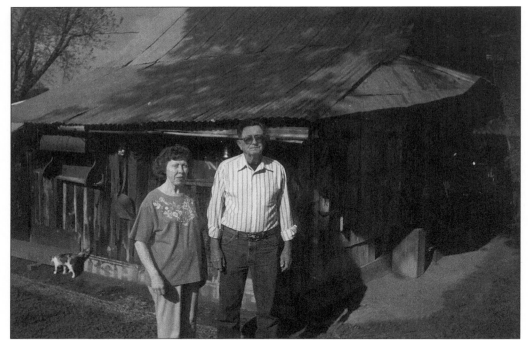

Martha and F.H. (Billy) Burns are standing beside his workshop. The Burns family was one of the first to settle in the southern section of Cherokee County. Mr. Burns' ancestors helped establish Carmel Presbyterian Church. He has conducted an extensive study into his family's history and the history of the church. One item of particular interest is that 11 family members fought for the Army of the Confederacy during the Civil War.

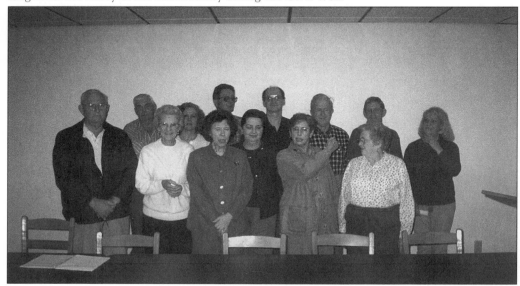

From left to right, Jerrell Whitten, Ben Smith, Grace Salvage, Diana Smith, Martha Burns, Billy Burns, Faye Amberson, Wayne Naugher, Perry Commer, William Jenkins, Geanne Jenkins, Jack Blair, and Glenda McElwee Naugher are members of the Cherokee County Genealogy Society. Each of them has traced their ancestral heritage.

Bill Minnix stands on the porch of an original settler's home. He moved it from the Claude Coheley Farm at Kirk's Grove to his yard. He then restored it and now stores artifacts there.

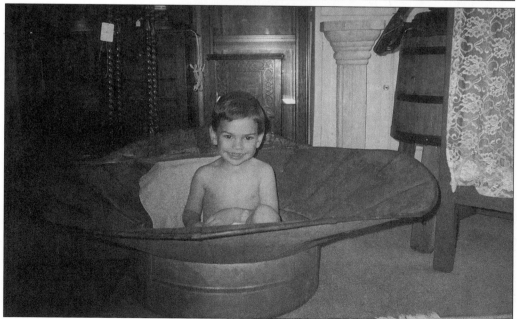

Three-year-old Sidney Maddox plays at taking a bath with his rubber duck in a pre-Civil War bathtub. He was a natural model. The tub is another one of the items that Bill Minnix has collected through the years.

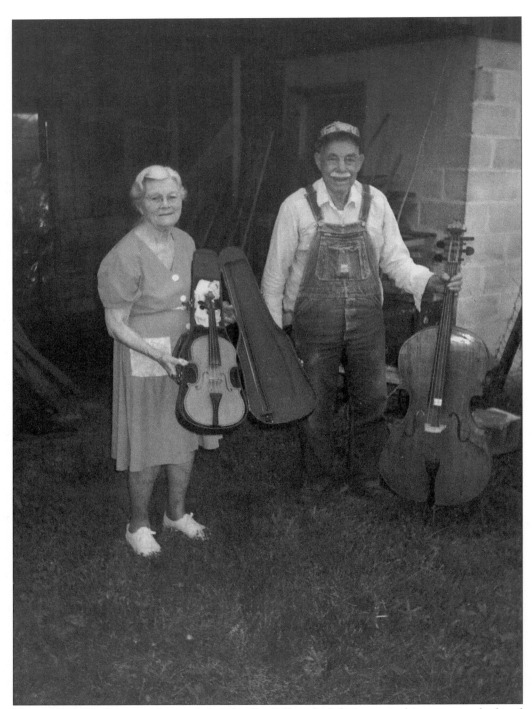

Ida and Bill Ward pose with a violin and cello. Bill crafted these musical instruments by hand from wood found on their property. He has also made guitars, other violins, and a grandfather clock—truly a man of many talents. Ida Ward has a milk-cow and she churns her own butter and buttermilk, a rare treat for anyone lucky enough to sample them.

Eight
INDUSTRY AND TRADE

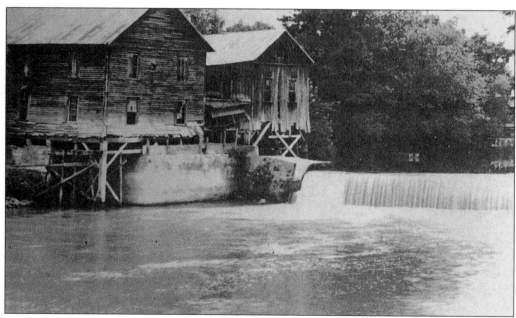

Gristmills were numerous along the rivers of Cherokee County from the mid-1800s through the mid-1900s. Cobia's Mill began operations in 1880 and operated until the creation of Weiss Lake in 1961. The water-powered mill ground corn into meal and wheat into flour, in addition to serving as a sawmill. Notice the covered bridge on the right side of the photograph.

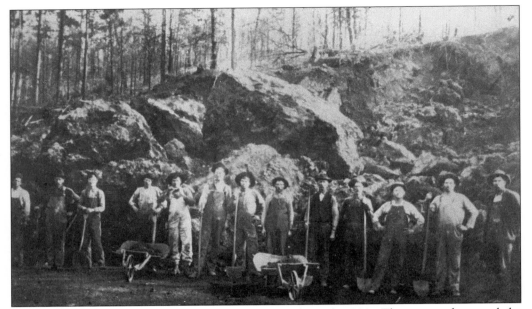

Pictured are unidentified ore miners at Rock Run, in the early 1900s. The ore was dug mostly by hand at this time, a far cry from the modern machinery used today. During the Civil War, a seventh of all iron produced in Alabama was mined in Cherokee County.

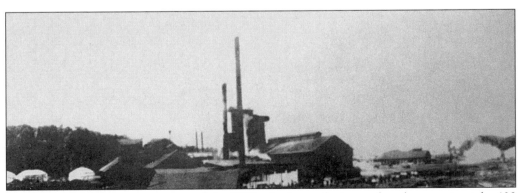

Rock Run Furnace was constructed in 1873. At its peak, it employed approximately 400 workers. It was just one of the furnaces that operated in Cherokee County between 1860 and the early 1900s. The Rock Run Furnace and the other furnaces used charcoal to heat the iron ore vats.

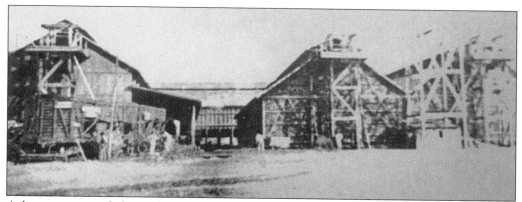

A large amount of charcoal was necessary to heat the furnaces to the desired temperature. These are the charcoal storage sheds at Rock Run. The area's forests were nearly cleared to furnish the wood to make the charcoal.

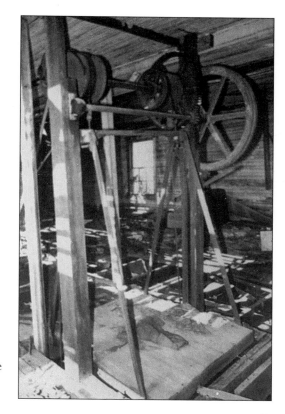

The commissary at Rock Run was one of the first buildings in Cherokee County to have an elevator (it was a crude freight elevator).

The commissary at most furnaces had a post office within them. Shown is the one at Rock Run.

The superintendent and general manager of the Rock Run Furnace, J.M. McGavin had this fine antebellum house built across the road from the furnace. Jerry Conley (standing on the porch) is currently restoring this house and the commissary.

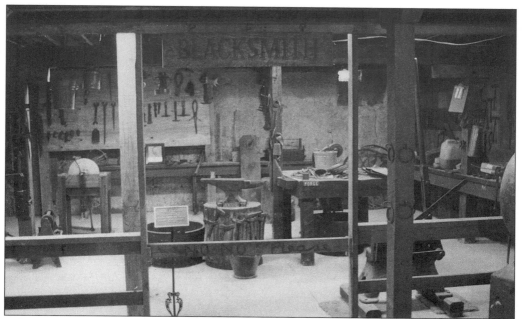

The Cherokee County History Museum has many displays. The one shown is an authentic blacksmith shop. It is equipped with the original tools and equipment used by Thomas Coffey and was positioned in the museum by his sons Tom and Charles.

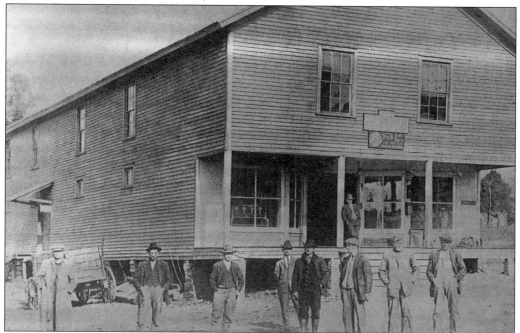

The Russell/Chesnut Company was the largest retail outlet in Centre during the early 1900s. Albert C. Van Pelt, George Brandon Russell, Clarence E. Chesnut, Harbin Coker, and R.C. Parks are in the picture. The man to the left, the two men to the right, and the man on the porch are unidentified.

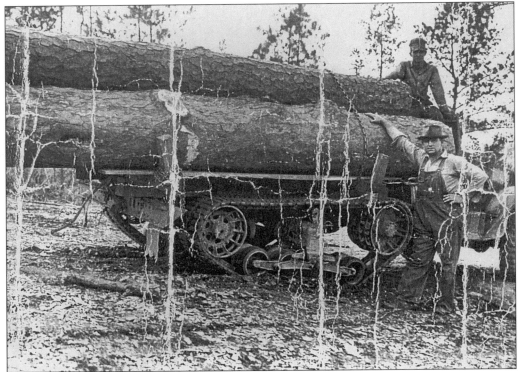

Logging has been a major industry in Cherokee County ever since the first riverboats left from here. These two unidentified men are using a tracked trailer. The tracks were originally part of a military vehicle.

G.W. Jordan founded Jordan's Gin, c. 1910. His son Hoyt continued the gin. He passed it to his sons Tom and George in 1948, and they still operate it today. This gin is the oldest continually operating business of its kind in the county.

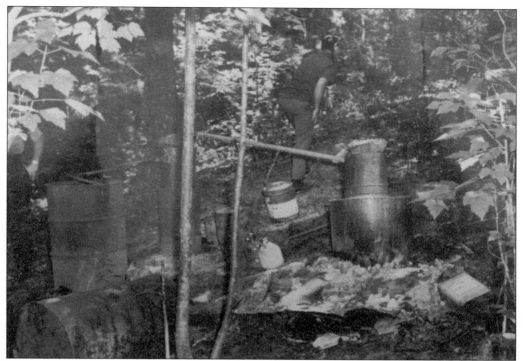

In 1887, Cherokee County passed the first prohibition law in the United States that gave growth to a new business. Liquor stills popped up in various locations and produced illegal whisky called moonshine. The picture shows a small still used to make moonshine.

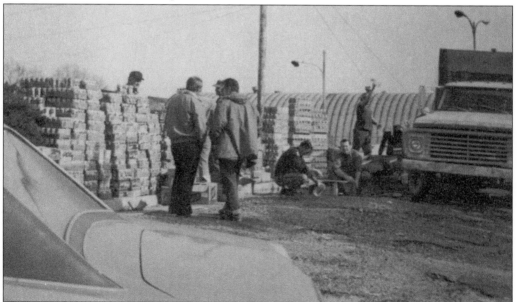

Sheriff C.M. Garrett, Herbert Acker, Kenneth Phillips, Jimmy Jordan, and John Tillery inspect confiscated beer. Cherokee is now and has been a dry county since 1887. Alcohol sales of any kind are illegal.

Old fashioned southern pulled barbecue is hard to find today but there is no shortage of it at Real-Pit Bar-B-Que in Centre. From left to right, Donna Huey, Virginia Bryer, Scott Wright, Lanny Starr Jr., and Lanny Starr (owner) are sitting at booths ready for a good meal of Bar-B-Que.

Hank and Harlin Richerson, owners of Richerson Plant Nursery, are standing to the left. The nursery has relocated to H-411 west and is now named Greens Nursery.

The Mid-Western Nurseries are one of the largest employers in Cherokee County. This company furnishes the entire eastern part of the United States with wholesale plants. Its customers are Home Depot, Wal-Mart, K-Mart, Lowes, and other large retailers. Another company, Dixie Green Greenhouses, wholesales bedding plants though out the same area. Thus, Cherokee County's second largest industry is plant nurseries.

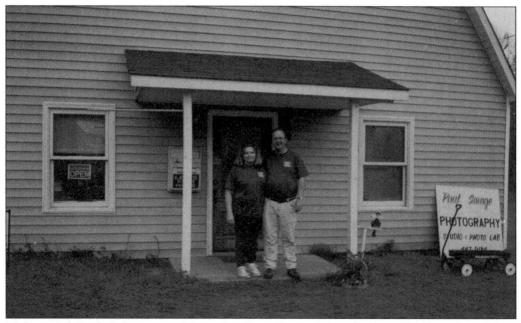

Melvia and Paul Salvage stand outside their photography shop in Pleasant Gap. Their customers come from all over Cherokee County and Piedmont. Paul takes school photographs in most of the schools in the surrounding area. Their customer growth is due to the friendly and personal attention that each gets. Their professionally produced pictures result in continued repeat business.

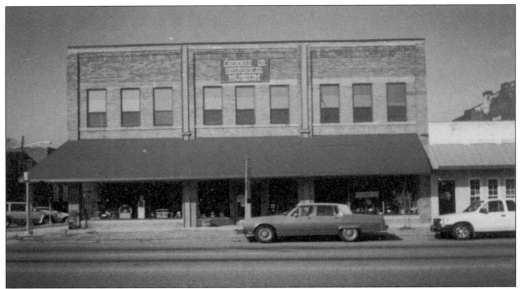

Cherokee County has one of the finest small town museums found anywhere. The Cherokee County Historical Museum is located in downtown Centre. Thousands of items on display tell the history of the area. Its hours are Tuesday through Saturday from 10 a.m. until 4 p.m.

The Cherokee County Electric Co-op furnishes electrical power to Cherokee County, DelKalb County, Marshall County, and Etowah County. The picture shows members of the co-op during an annual shareholders meeting.

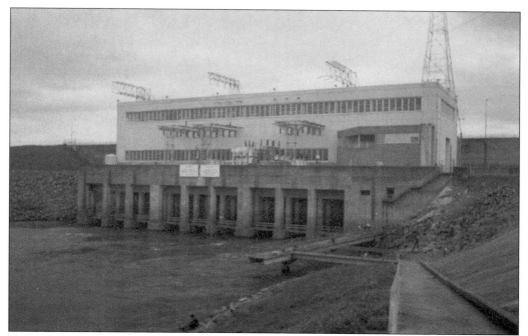

Hydroelectric generators receive their power from Lake Weiss. The lake was created by the construction of the dam and generating plant in the photograph. It is located on the Coosa River.

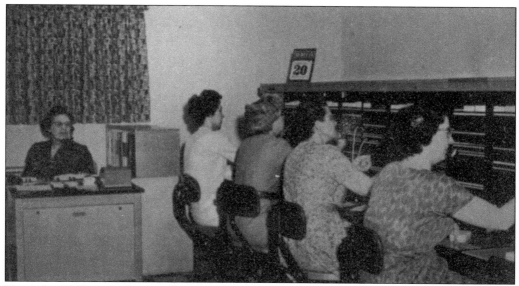

Until the 1960s, telephone calls went through a switchboard with live operators making the connections. Today, computers handle most of the calls. Lola Smith, Annora Ray Berske, Virginia Owens, Shirley Renfroe, and Betty White are shown handling the manual switchboard for Peoples Telephone Company, c. 1960.

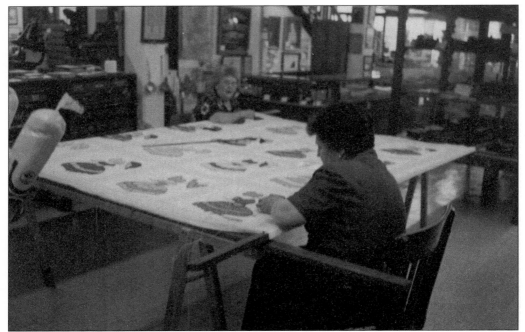

Frances Pollard and Erlene Harper are busy making a quilt at the Cherokee County Historical Museum. The quilts are sold as one of the sources of raising money for the museum.

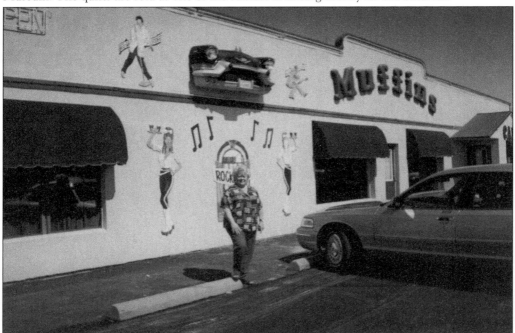

Muffins Caldwell invites you to get lost in the 1950s at Muffins 50's Cafe, where the decor and atmosphere are set in that decade. The cafe moved from Atlanta to Centre in 1987. Many famous people have visited, autographed a picture, and eaten at Muffins. Their pictures hang on the wall there.

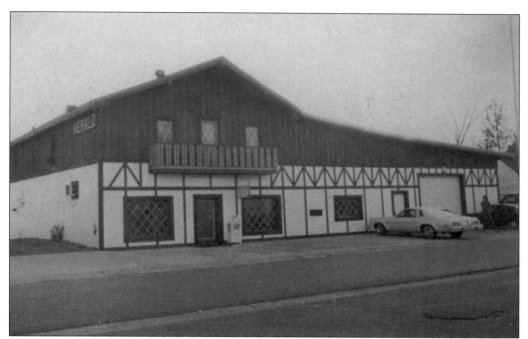

The *Cherokee Herald* newspaper is printed each Monday. It is one of the two newspapers currently printed in Cherokee County. The *Star* newspaper is the other. Terry Dean, Vicky Evans Roberson, and Kerry A. Yancer assisted in furnishing photographs for this book.

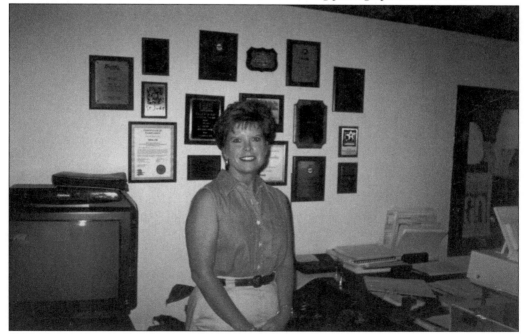

Shelia Richardson, office manager for WEIS Radio in Centre, poses before some of the awards earned by the station. The format for the station is country music during the day and gospel at night.

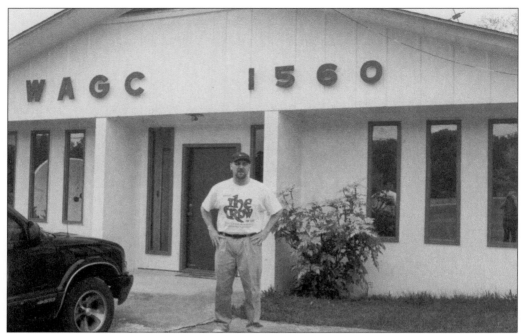

Tony M. Griffin began working at radio station WAGC at the age of 16. Twelve years later he owns the station, which has served the area for 40 years.

Workers at the Centre City Hall are always willing to assist visitors. Mary Lee Tucker, city clerk, allowed me to view old photographs in the city's archives. She is seen here in front of the city hall.

Nine
CHEROKEE COUNTY TOURIST ATTRACTIONS

Lake Weiss, with its 33,000 acres of water, 18 marinas, 7 public ramps, 10 camper parks, and various motels, attracts visitors from the entire Southeast. Pleasure boats, all types of fishing boats, jet-skis, campers, and sightseers can all be observed near the waters of the lake The lake powers a hydroelectric power plant, which furnishes electricity to the area.

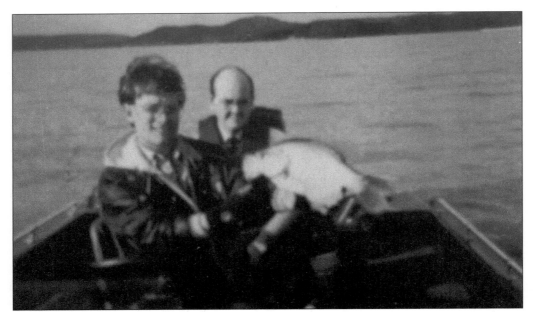

Each summer, a crappie tournament is held on Lake Weiss. Stan Jones, tournament director, has just finished tagging Tangle Free Tom (the fish) and is about to release him, *c.* 1990. The tournament judge, Phillip Jordan, is insuring that everything is done as required by the rules. The one who caught this fish was awarded the first prize of $65,000.

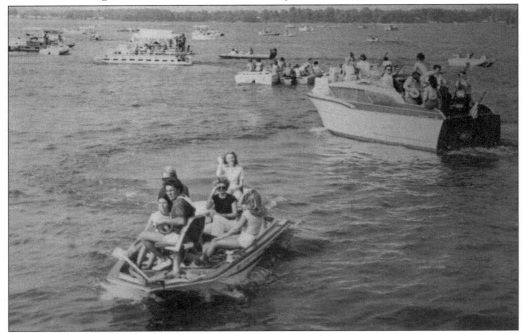

The Cherokee County Chamber of Commerce boat arcade is shown on its way up the Coosa River. Its objective is to meet with the Rome, GA, Chamber of Commerce at the Lock and Dam Park in Floyd County, GA. The chambers met, picnicked, and discussed matters of mutual interest.

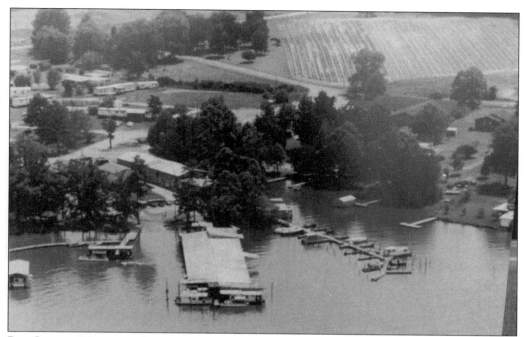

Bay Springs Marina and Motel is one of the most popular spots in Cherokee County for fishermen. There are 17 other marinas in the county.

Divers in the Coosa River have reported man-size catfish. This 18 pounder is no giant, but it will fillet out to a nice meal for several. The fish was landed from near the Dixie Queen. Bill Wesley is shown with his catch.

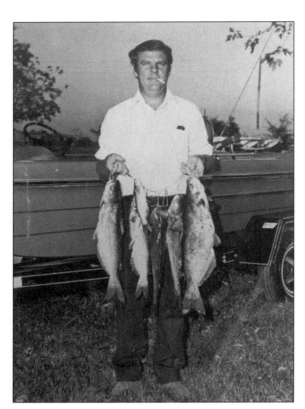

Pat Allen shows his morning catch from Lake Weiss. He was fishing near Pruett's Fish Camp. Notice that the fish in this chapter are of several different species. Other kinds of fish are also caught in Lake Weiss.

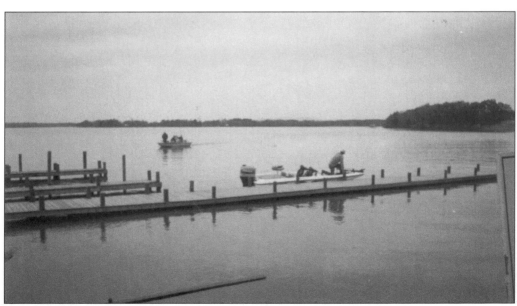

Fishermen from many states come to Lake Weiss and share in its abundance of crappie and other breeds of fish. The unidentified men in the two boats came from Illinois. One said that neighbors told them about the great fishing here.

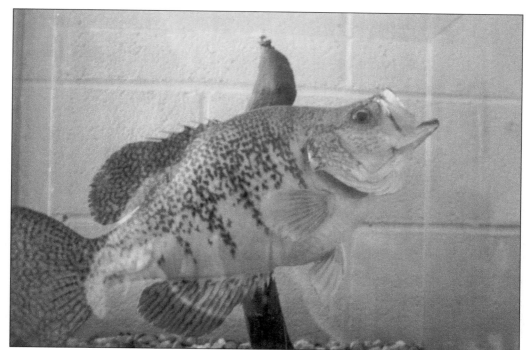

This 5 pound, 3 ounce crappie is on display in the lobby of the Cherokee County Chamber of Commerce. The name of the person who caught the fish is not known.

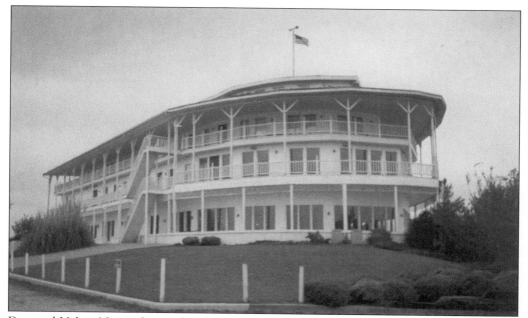

Don and Velma Norris designed and constructed the Alabama Queen, a building designed to look like a riverboat. The structure has a restaurant and a 35-room hotel. Each room has a view of Weiss Lake that can also be seen from any seat in the restaurant.

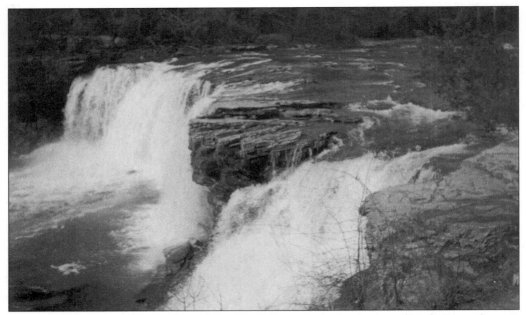

Little River Falls is an awe-striking sight. The falls mark the beginning of Little River Canyon National Preserve. This preserve was established by an Act of Congress on October 21, 1992, to protect and preserve the natural, scenic, recreational, and cultural resources in the area. Parking, restrooms, and picnic tables are available near the falls.

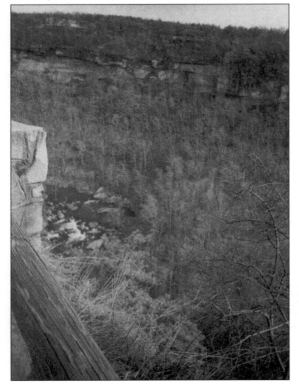

This view of Little River Canyon is just one of the many provided during the 18-mile drive along the canyon rim. The canyon is between 600 and 700 feet deep. The Little River and other forces of nature carved it through millions of years. The river provides an outstanding canoe trip.

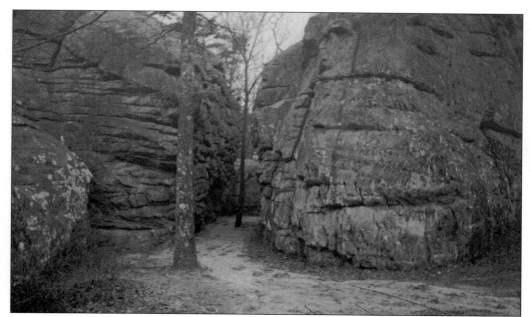

This is one of the paths in Cherokee Rock Village Park. This is the highest point of Lookout Mountain within Cherokee County. Picnic tables are provided and many scenic points grace the area.

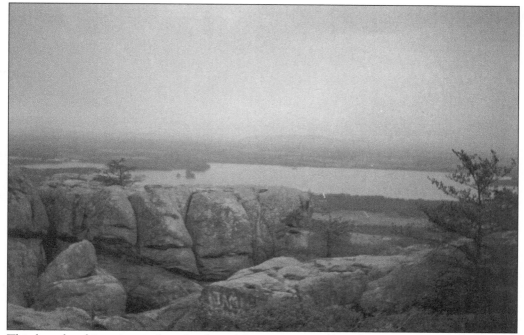

This breath-taking view is from Lookout Mountain at an altitude of 1,690 feet. Part of Lake Weiss is visible and Weisner Mountain is in the background. Many such viewpoints are available from the mountain.

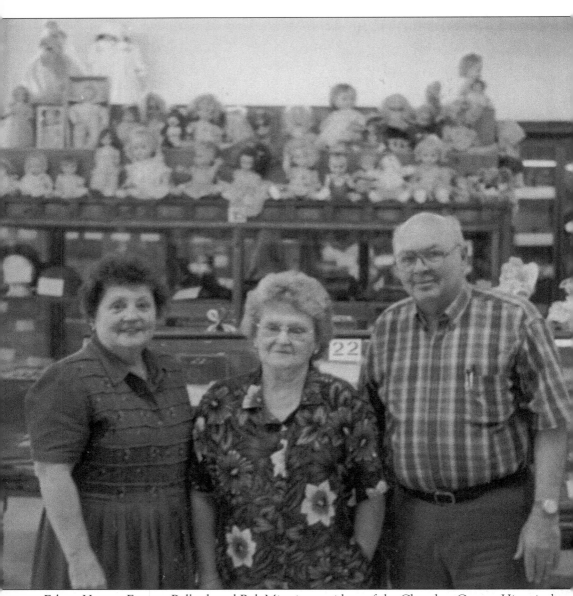

Erlene Harper, Frances Pollard, and Bob Minnix, president of the Cherokee County Historical Museum Association, are standing near some of the many display cases within the museum. The museum boasts one of the best doll collections anywhere. John Garmon, Ann Jordan, Nell Killgore, Christine McCarley, Earl Gardner, Jack Morgan, Charles Moody, Al Shoemaker, Sybil Ellis, and Sue Ellis are the board of directors of the museum.